FRENCH PHOTOGRAPHY

FROM ITS ORIGINS TO THE PRESENT

FRENCH PHOTOGRAPHY
FROM ITS ORIGINS TO THE PRESENT

BY CLAUDE NORI

TRANSLATED FROM THE FRENCH BY LYDIA DAVIS

PANTHEON BOOKS / NEW YORK

ACKNOWLEDGMENTS

I would like to thank all the photographers whose pictures appear in this book for their helpful cooperation. I would also like to thank Pierre Gassman, Romeo Martinez, Jean-Claude Lemagny and Carole Naggar, whose advice and knowledge have been of great help in carrying out this project.

—CLAUDE NORI, 1978

Library of Congress Cataloging in Publication Data
Nori, Claude.
French photography from its origins to the present.
Translation of *La photographie française des origines à nos jours.*
1. Photography—France—History. I. Title.
TR71.N6713 770'.944 78-24709
ISBN 0-394-50670-7
ISBN 0-394-73784-9 pbk.

Manufactured in the United States of America
First American Edition

CONTENTS

Acknowledgments iv

The Inventors 1

The Pioneers of the Industry 7

Pictorialism and the "Art" Photograph 13

The Documentary Photograph 19

Paris and the Avant-Garde 33

The Birth of a Sense of Mission (1930–1945) 59

Humanistic Reportage 63

Photojournalism 85

The Naturalists 107

Survivors of Fashion and Advertising 117

After 1968 127

List of Photographers Cited 168

Selected Bibliography 169

About the Author 170

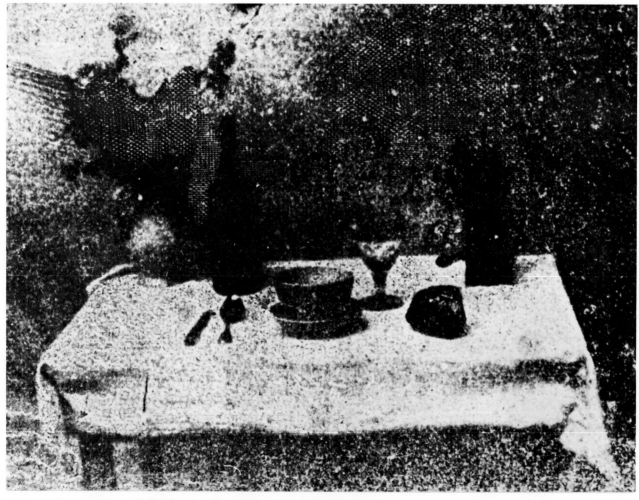

JOSEPH NICÉPHORE NIÉPCE, *Still Life*, 1822 (Société Française de Photographie)

Photography, which is now an integral part of our lives, came into being in Europe about 1830 as the result of several simultaneous and complementary experiments in optics and chemistry. The middle class, which had come to power at the beginning of the nineteenth century, enjoyed an optimism linked to the idea of progress and humanistic values, and it needed a sympathetic mirror to give it a flattering image. No wonder this bourgeoisie eagerly sought a way of using the latest technology to make a lasting record of itself, a way of existing for posterity whatever the cost. As it turned out, the cost was not very high.

Ever since the Renaissance, artists had been using the *camera obscura* as a means of solving problems of perspective. The principle of the camera obscura is very simple: light enters a hermetically sealed chamber through a tiny hole and an inverted image of the external scene forms on the opposite wall. In 1760 Etienne de Silhouette, comptroller general of Paris, used this quick and inexpensive technique to reproduce his customers' profiles; he was commercializing the age-old method employed by the shadow theater.

In 1786, Gilles-Louis Chrétien invented the *physionotrace* and used it to engrave the silhouettes of the heroes of the French Revolution on copper. This process was refined by William Hyde Wollaston when he created his *camera lucida*, and refined further by Charles Chevalier.

Several centuries before Christ the effect of light on certain surfaces, such as rugs and fabrics, was already known to painters who had to find a quick way to capture colors.

At the beginning of the eighteenth century, Johann Heinrich Schulze demonstrated that silver nitrate reacted to light, and in 1780 J. Charles, a French scientist, produced silhouettes on a paper base that had been sensitized with silver nitrate.

From then on, the principle of photography—or "image drawn by light"—was in the air. All that remained was to bring together the different discoveries in optics and chemistry.

JOSEPH NICÉPHORE NIÉPCE AND HELIOGRAPHY (1765–1833)

Joseph Nicéphore Niépce, a landowner from Châlon-sur-Saône, spent many years devoting himself to improving the technique of lithography, which was very much in fashion at that time. People were infatuated with pictures of all kinds, and there was a growing market for anything related to the mechanical reproduction of images. Since he did not have the artistic talent to make drawings of what he wanted to reproduce, Niépce thought of using light. In 1824 he wrote an account of his discovery, which he called *heliography*: "The discovery I have made and which I call heliography consists of using the effect of light to reproduce spontaneously the images obtained in the camera obscura, with gradations of tone from black to white." To do this, he coated a copper plate with bitumen of Judea (asphaltum), a varnish commonly used by the engravers of the period, and exposed it in a camera obscura (dark room) constructed by the Paris optician Charles Chevalier. After a certain length of time, which varied according to the intensity of the light, he would dip the plate into a solvent and the image, until then invisible, would appear. The first

plate image produced by light using a camera obscura was made by Nicéphore Niépce in 1822. He subsequently performed other experiments with plates and paper bases but did not succeed in fixing permanently the images obtained.

LOUIS JACQUES MANDÉ DAGUERRE (1787–1851)

One man who found Niépce's work extremely interesting was a Parisian artist who operated a *diorama*, a display he had devised consisting of huge panoramic *trompe l'oeil* images lit from above or behind and made to look as realistic as possible. Louis Jacques Mandé Daguerre was already using the camera obscura to create these enormous pictures, and he correctly thought that Niépce's research could help him perfect his show. In January 1826 he wrote Niépce a letter telling him that he had produced heliographs and suggesting the two of them should form a partnership. In 1829, after three years during which they had exchanged very distrustful letters, Daguerre visited Châlon-sur-Saône and signed a partnership agreement with Niépce for a period of ten years.

Niépce died in 1833 and Daguerre continued to "perfect" his dead associate's discoveries. All he actually did was modify Niépce's technique slightly, while falsely taking credit for the discovery of hyposulphite, a substance used to fix images. (The effect of hyposulphite had been described in 1839 by Sir John Herschel, an English astronomer who was also the first to understand the negative-positive process—the basis of modern photography.) Daguerre secretly demonstrated his "invention"—which he pompously called the *daguerreotype*—to François Arago, a well-known astronomer, and on January 7, 1839, Arago reported the news to the Academy of Sciences in Paris. The French government gave Daguerre a comfortable pension. Isidore, Niépce's son, received a smaller pension and dropped out of the public eye, at the very time he was attempting to prove that the daguerreotype method had been invented by his own father, not by Daguerre. The ensuing publicity ensured the success of daguerreotypes in the western world; they became the joy and delight of a class enchanted by the idea of having its picture taken.

Yet daguerreotypes were inconvenient: there was only one proof and the plate had to be tilted at a certain angle for the image to be clearly visible. They could, however, be used as matrices for making engravings or lithographs. Within twenty years, daguerreotypes gave way to other processes which were eventually to lead to modern photography—the making of one or more prints from a negative. The fact that daguerreotypes were usually destroyed to make engravings has caused them to become quite rare, and they are prized by collectors.

HYPPOLYTE BAYARD (1801–1887)

Hyppolyte Bayard, a minor employee of the Ministry of Finance in Paris, helped to advance photography with the first exhibition of photographs on paper on June 24, 1839, well before the Academy of Sciences published an account of Daguerre's process. He obtained surprising results using paper sensitized with silver chloride and soaked in potassium iodide; he was able to produce a direct copy, though only one at a time. But despite the fact that his pictures, many of which were almost surreal, reflected undeniable artistic talent, he was completely ignored by the critics of his day. According to one anecdote, he took a photograph of himself posing as a corpse, on the back of which he wrote: "This is the corpse of the late Bayard. . . . The Academy, the King, and all who saw his pictures admired them as you are doing now. This brought him great honor but did not earn him a *sou*. The government, which gave a great deal to M. Daguerre, said it could do nothing for M. Bayard and the poor man drowned himself."

At the same time in England, William Henry Fox Talbot, a famous mathematician, discovered the principle of present-day photography and called it the *calotype*. In this process, the picture emerges during development rather than at the time of the shooting, and a negative proof is created that allows an unlimited number of positive copies of the picture to be printed on sensitized paper.

HYPPOLITE BAYARD: "This is the corpse of the late Bayard . . ." (Société Française de Photographie)

HYPPOLITE BAYARD, *Still Life*, 1839 (Société Française de Photographie)

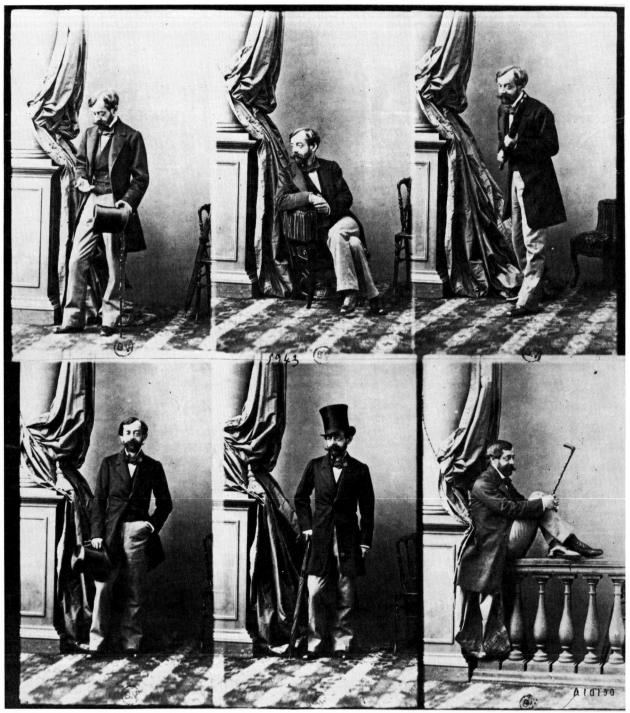

ADOLPHE DISDÉRI (Bibliothèque Nationale, Paris)

6

Photography's immense popularity during the second half of the nineteenth century gradually reached every level of society. People lined up to get into photography studios, and in 1852 in France millions of portraits were taken. This eventually led to a profound change in people's philosophical perception of the world. Because a person could now see the foreshadowing of his own death captured in each portrait, he became filled with an almost sacrilegious determination to arrest life, to hold back the passage of time. It was as though man were trying to control his own destiny.

As photography became a prosperous industry, more and more scholars, writers, and politicians began to be aware of its extraordinary possibilities—in the social realm as well as in the realms of art and science—even though a very small number of them, including Charles Baudelaire, believed photography to be a "vulgar" proof of the "stupidity of the public."

The advent of photography, however—"total realism" achieved mechanically at the expense of the human touch—coincided with the era of capitalism and materialistic thinking, perfectly mirroring the spirit of the times in its fascination with scientific and "magical" properties. For this reason, it can be considered the first great wonder and the first great myth of industrial civilization, a development that ultimately led to the birth of the seventh art—cinematography.

ADOLPHE-EUGÈNE DISDÉRI (1819–1890)

In 1854, Adolphe-Eugène Disdéri dealt a fatal blow to daguerreotypes by creating his *carte de visite* process. This made it possible to produce a series of portraits or views using a camera of his own invention containing six to eight lenses that could produce a succession of images. Disdéri then mounted the developed pictures on pieces of cardboard. Disdéri's idea, commercially and technically brilliant, considerably lowered the cost of producing portraits, since eight photographs could be taken at once, and it became so popular that it was soon adopted all over the world. The process was so simple that many people without any artistic pretensions used it to make a fortune. Disdéri's invention unwittingly paved the way for family photograph albums, identification photographs, and the use of photographs by police as evidence in court.

NADAR (1820–1910)

At the same time that the carte-de-visite process was being perfected, a group of portrait artists who lived the "Bohemian" life and were part of the artistic élite of the École Française, tried to turn portrait photography into a legitimate art. They did their work on a small scale and used large-plate cameras, taking pictures of clients selected from Parisian high society.

Antony Samuel Adam-Salomon, Pierre Petit, Étienne Cajart never achieved the renown that Nadar did in his own lifetime. Nadar, whose real name was Gaspar Félix Tournachon, was also involved in the theater, literature, and drawing, and even took the first aerial photograph in 1858 from a hot-air balloon. His studio, which he opened with his brother Adrien in 1853, was visited by the most fashionable personages of the time, and in 1874 it served as the gallery for the first exhibition of French Impressionists rejected by the Louvre. Nadar placed great emphasis on the importance of the inner psychology of his subjects, whom he

NADAR (Bibliothèque Nationale, Paris)

NADAR (Bibliothèque Nationale, Paris)

NADAR (Bibliothèque Nationale, Paris)

NADAR (Bibliothèque Nationale, Paris)

usually photographed from a three-quarters angle against a plain dark background, under the diffused light from the glass roof of his studio. He was also one of the first to use electric light for certain shots.

Nadar remains the first great witness of his era, a conscientious reporter whose photographs documented the entire generation of Second Empire privileged classes and intellectuals.

ÉTIENNE JULES MAREY (1830–1904)

The originality of Jules Marey's approach to photography cannot be fully understood unless one takes into account the fact that his first profession was as a physiologist, and that in this field he showed incredible ingenuity in perfecting and inventing instruments for recording living phenomena. In 1881, while studying the flight of birds as part of his research into the possible development of flying machines, Marey came across the work of the American Eadweard Muybridge, who since 1878 had succeeded in capturing the motion of a horse by using a battery of twelve cameras that went off one after another.

Marey asked the American to try to photograph birds in flight, but was disappointed by the results and set to work on constructing a photographic gun which was completed in 1882. Several months later, dissatisfied with his gun because the images it obtained were not sharp enough, Marey went on to invent the *chronophotograph*, which allowed him to obtain a perfect reconstruction of movement with all its metamorphoses. He used a camera containing a rotary shutter that at each turn uncovered the sensitized plate on which his subjects appeared dressed in white against a stark black background. In 1892 Marey designed a chronophotographic projector, but did not show it to the Academy of Sciences because he had not overcome the problem of skipping images.

His collaborator, Georges Demeny, later developed Marey's projector into a *phonoscope*, which produced the illusion of facial movements in the act of speech (the first animated picture was one of Demeny himself saying *"vive la France!"*). Beginning in 1895, patents for the production of animated pictures were assigned at a frenetic rate, and on December 28, 1895, the Lumière brothers mounted their first public cinematographic projection after a heavy advertising campaign. The motion-picture show was born. It was left to Meliès to turn it into a form of expression.

Jules Marey's artistic modernism influenced several painters, including Marcel Duchamp (see his "Nude Descending a Staircase") and the artists involved in Futurism.

LOUIS DÉSIRÉ BLANQUART-EVRARD (1802–1872): *The Photography Book*

Between 1847 and 1851 Blanquart-Evrard, a chemist and painter born in Lille in 1802, devoted himself to turning photography into a technique for mass-producing reproductions. Until then, it had taken an entire day to make four or five positive prints from a single negative; in 1851 Blanquart-Evrard succeeded in turning out three hundred proofs a day using gallic acid to develop the latent image. One year later he opened a business called "L'Imprimerie Photographique," which employed about fifty people and could produce an indefinite number of prints for photographers (among them Le Secq and Bayard) at a very low price. But Blanquart-Evrard, well aware that photography could benefit from mass distribution, went into publishing as well. Most of the books he published, and which contained original photographs, were primarily of ethnological, archaeological, and touristic interest, but some included reproductions of works of art.

Since 1851, therefore, new areas of knowledge and communication were opened through the medium of photographically illustrated books, which created an independent language somewhere between realism and poetry.

9

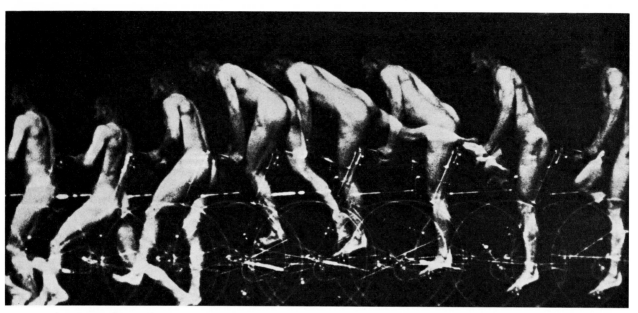

JULES MAREY, *Cinémathèque*, Paris

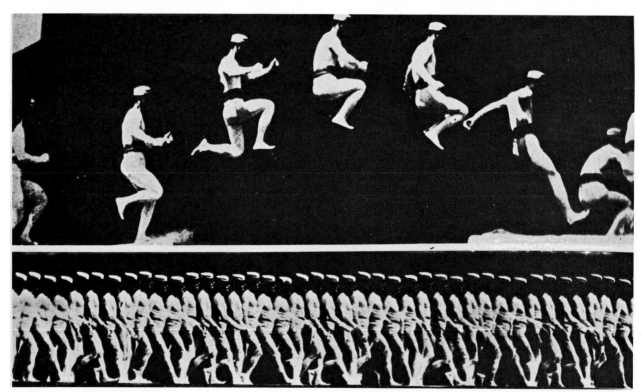

JULES MAREY, *Cinémathèque*, Paris

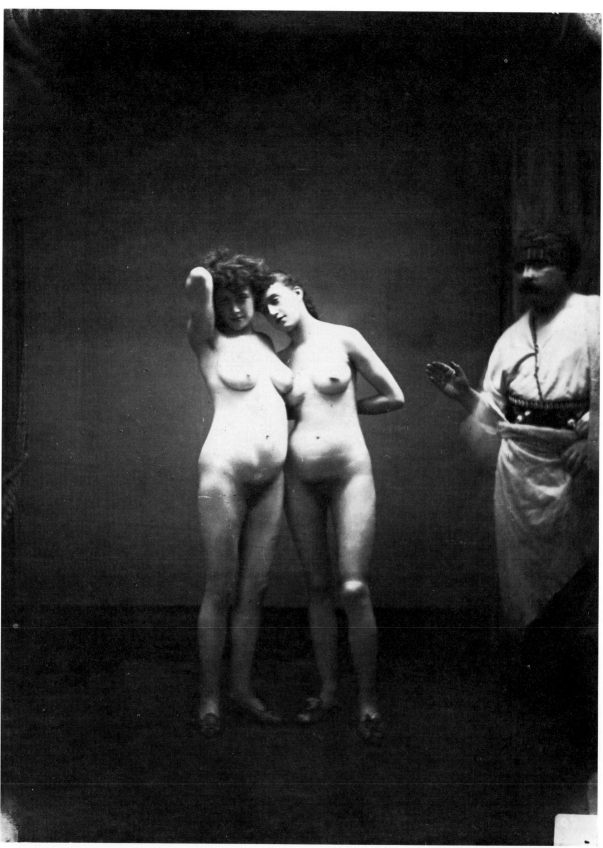

ANONYMOUS (Société Française de Photographie)

PICTORIALISM AND THE "ART" PHOTOGRAPH

While photographers were deliberately seeking to record everyday life as faithfully as possible, thus developing a new language unfettered by sterile artistic traditions, a profoundly reactionary movement was forming elsewhere in Europe and America that was eventually to become an obstacle in the path of photography's future. The pictorialists kept protesting that photography was not an art but simply a technique for reproducing images—so easy to use that any fool could do it. Such an élitist attitude can only be understood by taking into account the fact that most of the pictorialists were mediocre and frustrated painters or wealthy amateurs who wanted to preserve the status of the unique work of art. According to them, in fact, only photographs that resembled paintings could be considered art. They therefore based their work on the most time-worn models, chose only the most traditional subjects, and indulged freely in the Victorian allegories then fashionable. What mattered was not so much what they portrayed as how it was portrayed. This rejection of things as they were, this flight from reality, this isolation in an aristocratic and idealized world led them to use the soft-focus technique which David Hamilton was to perfect in magazines and posters a hundred years later.

Although in some circles photography was a hobby and a distinguished pastime, it was sometimes also used as a form of therapy, an excuse to liberate sexual drives in a puritanical society. Pornographic pictures proliferated in this environment, where the forbidden was a stimulant, and were sold clandestinely through a quasi-illegal network.

The two most influential figures in the French pictorialist movement became prominent first in the Paris Photo-Club, where the élite met every Wednesday, and later in the *Revue Photographique*, which was started in 1902. Commandant Puyo (1857–1933) and Robert Demachy (1859–1936) wrote books about photography in which they explained their respective theories and practices at length. Both achieved their effects either in the darkroom or by working on the print itself in order to eliminate the cold and mechanical realism recorded by the lens, in an attempt to come as close as possible to the Impressionist "touch." Robert Demachy became the undisputed master of "gum bichromate and oil," with which he could obtain colored pictures somewhat similar to lithographs at the moment they are run off. Commandant Puyo broadened his camera technique by using special lenses equipped with chromatic aberrations. Through the use of varying darkroom processes, the two men often managed to obtain very different pictures from the same negative. For example, the pictures obtained directly from the untouched negative are striking in their realism and their air of decadence and "kitsch."

Although the reign of pictorialism was brief and did not have much influence on the final direction of photography, its effect can still be perceived in the art photographs so highly prized by certain photography clubs, in which the study of photography is consistently guided by the rules of pictorialism.

ROBERT DEMACHY (Société Française de Photographie)

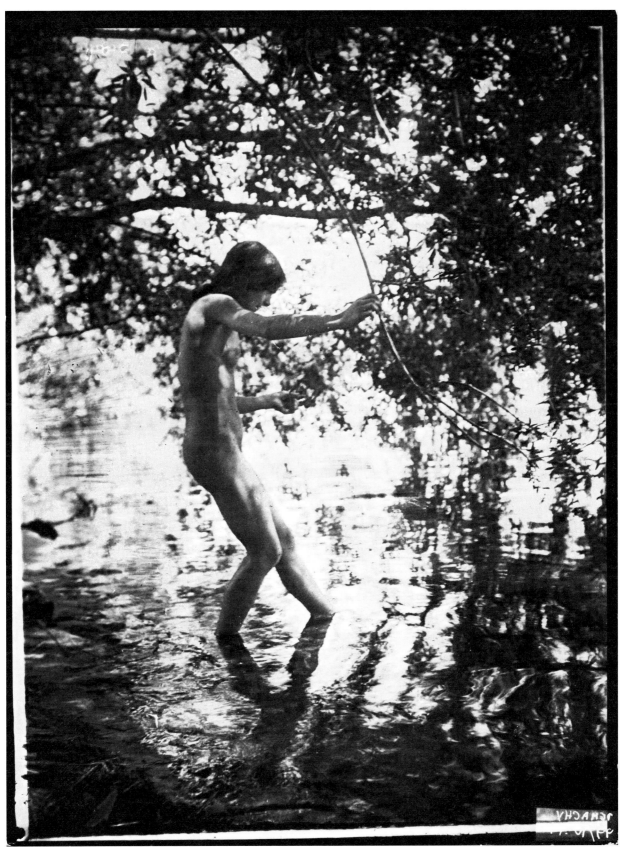

ROBERT DEMACHY (Société Française de Photographie)

PUYO (Société Française de Photographie)

PUYO (Société Française de Photographie)

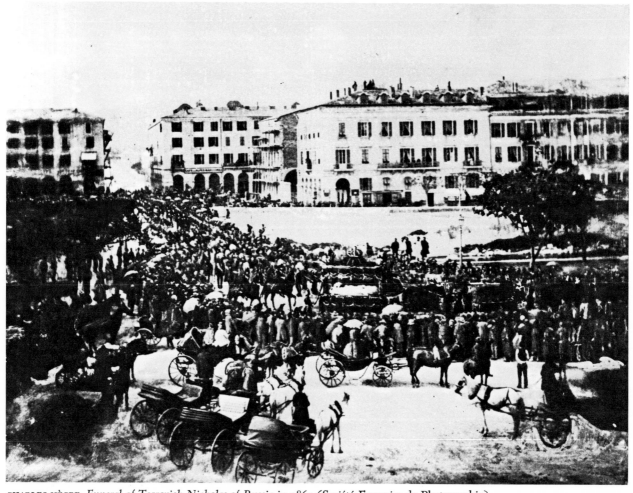

CHARLES NÈGRE, *Funeral of Tsarevich Nicholas of Russia in 1865* (Société Française de Photographie)

THE DOCUMENTARY PHOTOGRAPH

"One had to admit that photography and painting were in no way related, and that if there was such a thing as an art of photography it had to be sought within photography itself and nowhere else. The first thing was to start with a clear image, not to be so stupid as to deny oneself that, and to let it be itself ràther than a vague imitation of a questionable kind of painting which people had stopped discussing long ago. Without boasting, I can say that I am one of those who crushed pictorialism for good. The imperatives of this pure photography, defined by Frédéric Dillaye, of which Atget has left marvelous examples, had to triumph in the end because of my work and that of a new school of young photographers who wanted to be photographers and nothing else."

This firm, definitive stand was taken by Daniel Masclet (1892–1969), a photographer and theoretician who had sided with the pictorialists for a time but eventually opposed them when he became the spokesman for "pure" photography, which went beyond appearances to find the truth and whose rules in the United States were defined by Stieglitz.

By the end of the nineteenth century, the rapid development of mechanical means of reproducing pictures, linked to the many improvements made in cameras—including the creation of roll film, portable cameras, and so on—made it possible to use photogravure and process engraving to produce quality prints, meaning that a large number of pictures could be printed at a modest price.

Because of books and other print media, it became easier to print thousands and even millions of copies of photographs, thus attracting a growing number of photographers who saw this as an extraordinary way of circulating their work. From then on, many of them would walk the streets of big cities, recording extreme poverty, unemployment and exploitation, and revealing the horrors of war in an ever-changing world. The photographs had to be direct, honest, immediate, and sharp, without any apparent estheticism; they had to touch and affect people, with an objectivity and realism that would make them unquestionably authentic. Yet though a large number of those documentary photographers would not use the word "esthetic" in connection with their pictures, it was nonetheless true that some of them drew upon their artistic talents and their compassion to give life to people and events. The "art photograph" was consigned to oblivion in amateur photography clubs or cultural monuments forever dedicated to technical and formal considerations.

The world-wide economic crisis of the thirties led a number of painters and creative artists further into realism. In America, for example, Jacob A. Riis and Lewis Hine, among others, traveled the countryside taking pictures of the working and living conditions of the underprivileged; they used their magnesium cartridges to photograph interiors, revealing every sordid detail. Their pictures provoked indignation among the public and forced the government to pass new and more humane laws, while it continued to safeguard the privileges of the upper classes. Day after day photogra-

CHARLES NÈGRE (Société Française de Photographie)

phers in France, especially in Paris, were gradually amassing a collection of pictures that would permit future generations to make sociological statements about their country.

Henri Le Secq (1818–1882) worked in an official capacity for the government as a photographer of French architecture. He photographed cathedrals steadily from 1850 to 1855, and put together one of the first illustrated books in France, *Amiens, recueil de photographies* (*Amiens, a Collection of Photographs*).

Gustave Le Gray, Charles Nègre, Jules Beau, the Seeberger brothers, Victor Regnault and many others were interested in the folkloric and anecdotal aspects of the daily life of the French. Nothing escaped them; they explored every element of human activity. Morlock photographed the first workers' demonstrations, taking pictures of them in the Singer or Félix Potin factories. A picture of a working-class family's dining room shows there was no electricity; at that time it was too expensive. Groups of women photographed together smile because their working day had been reduced to ten hours! The picture of the first woman billposter, taken in 1900, was a political event. Dornac published *Nos contemporains chez eux* (*Our Contemporaries at Home*), a series of photographs of the personalities of the period—Pierre and Marie Curie, Renoir, Rodin, Anatole France, and others—taken at home or at work. Although it was against the law to take pictures in a public place without permission, the police became less and less strict and did not interfere —proof that photography had a softening effect on people's behavior! Photography was represented at the 1900 World's Fair, where pictures of French schools and school children were shown: a law had recently been passed requiring children to attend school until the age of thirteen.

While some photographers were growing rich making portraits of the upper middle class in studios lined with tapestries and full of antique statues, others were taking active part in the political events of the day. Braquehais, for instance, gave his services to the Communards in 1871 and stood in the middle of the street photographing the barricades and the fighting. E. Appert, working for the party in power and the army, eagerly applied himself to the mean and ignoble work of portraying the barbarity of the internationalists in a series called *Les crimes de la Commune* (*The Crimes of the Commune*). This book became a best seller among the middle class, who delightedly regarded it as vindication of their part in fomenting the revolt. By creating falsified historical reconstructions, photomontages, and the use of retouched photographs, Appert was one of the first to use photography as an instrument of propaganda.

Yet two men who were almost completely unknown in their lifetime, and who took their pictures without any ultimate artistic goal in mind, injected photography with new vitality. The work of Eugène Atget is still striking today because his vision was so modern; methodically and objectively he recorded the banality of daily life in a city undergoing extreme upheaval. Jacques-Henri Lartigue's legacy could be described as the visual diary of an amateur amusing himself by portraying the events of his private life day by day, unaware that he was documenting what amounted to the photograph album of an entire generation.

VICTOR REGNAULT (Société Française de Photographie)

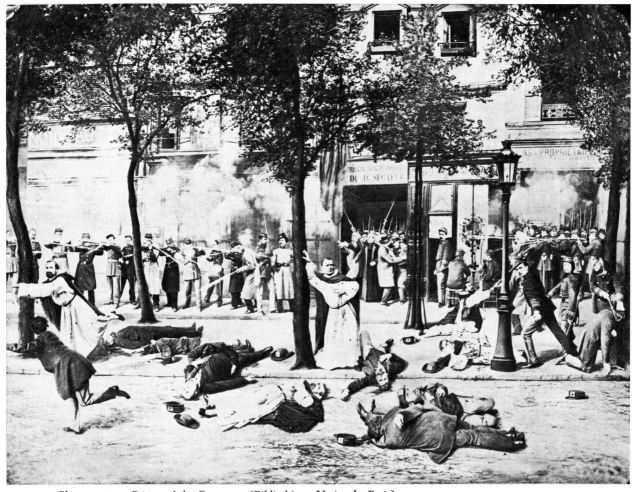

E. APPERT, Photomontage, *Crimes of the Commune* (Bibliothèque Nationale, Paris)

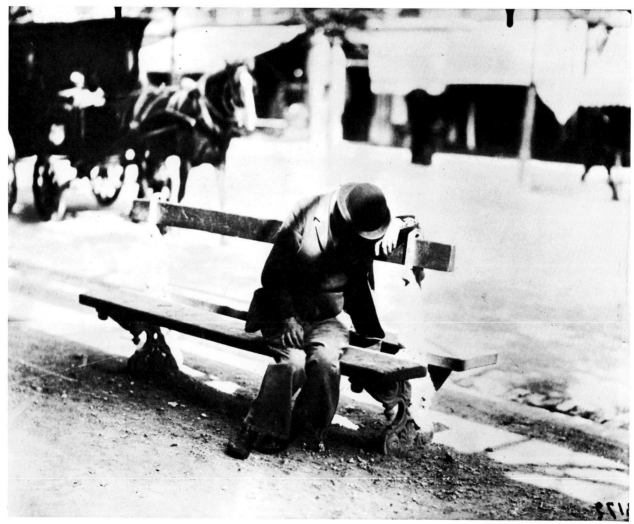

EUGÈNE ATGET, *Tramp on a Bench*, 1898 (Bibliothèque Nationale, Paris)

EUGÈNE ATGET (Bibliothèque Nationale, Paris)

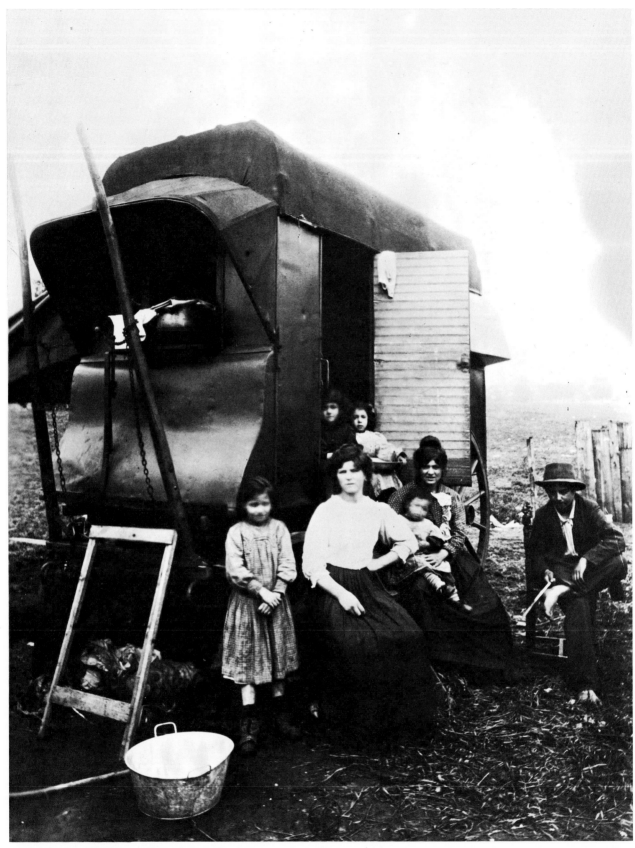

EUGÈNE ATGET (Bibliothèque Nationale, Paris)

JEAN EUGÈNE AUGUSTE ATGET
(1857–1927)

Eugène Atget was born on February 12, 1857, in Livourne, a town in southwest France, and lost his parents when very young. He left home with his uncle and went to Paris. After studying in a seminary he took up acting, his real passion. As an actor he was a failure; he played only very minor roles or served as understudy, yet this was where he met Valentine Delafosse, a young actress with whom he remained for the rest of his life. By 1898, past forty, he was an embittered man, out of work and rejected by the theater. After several attempts at painting, he thought of taking photographs for his artist friends in Montparnasse, who needed subjects for their canvases. Every day he would set off at dawn, bending under his large camera with its 18 × 24 cm. bellows—it weighed almost 22 pounds—to record the daily appearance of a Paris that was undergoing dramatic changes. With remarkable instinct he photographed everything that seemed interesting to him, everything he liked, everything picturesque, but also everything that was about to disappear: the small tradesmen, the prostitutes, the garbage collectors, the shop signs, the kiosks, the street urinals, the shop windows, the fortifications, the private mansions, the Bièvre, the fountains, the park of Saint-Cloud, and the Zone.

At that time Napoleon III had passed a law stipulating that every street had to be photographed before, during and after its demolition. Atget made a modest living selling his pictures to the Department of Historical Monuments and other promoters, and by taking his pictures around to the painters, whom he visited regularly in their studios. The only publication of his work during his lifetime was a series of picture postcards depicting the "small trades" of Paris. After the death of his companion in 1926, he lived alone and miserable, dying a year later on August 4, 1927, on the landing before the door of his home in the rue Campagne-Première.

The young American photographer Berenice Abbott, who met Atget through Man Ray, carried home with her nearly two thousand plates taken by Atget, whom she deeply admired. Even though these plates, which had been neglected by official organizations and sold at a very low price, were of only moderate interest, Berenice Abbott publicized and promoted Atget's work. As the years went by, Atget's influence grew until he became a legend, and all sorts of photographers tried to appropriate his work in defense of their own concerns, or attributed artistic intentions to him that he had never had. Today Atget, the simple itinerant photographer, has become a symbol of the ideal documentary photographer, one who intensely loves people, who stubbornly examines the urban environment and records it in a simple and condensed style. Atget never forgot his primary function: to be a witness.

JACQUES-HENRI LARTIGUE
(1894–)

a time forever past

"Whereas his contemporaries followed traditions created by earlier photographers, he did something that no other photographer had ever done before or would do after: he photographed his own life. It was as though he knew instinctively from the very beginning that the secret of life was in each person's humdrum, day-to-day existence." (From Richard Avedon's afterword to *Instants de ma vie* (*Moments from My Life*), February 15, 1970, Éditions du Chêne).

Jacques-Henri Lartigue is undoubtedly the child prodigy of photography. He took his first pictures at the age of seven with a camera given him by his father, a rich banker. In his private diary, which he filled daily with notes, drawings, and photographs, he wrote: "I'll be able to photograph everything! Everything! Everything! Now, maybe I won't be sorry to return to Paris, because I will bring back all my pictures of the country. Before, I would say to Papa: 'Photograph this,

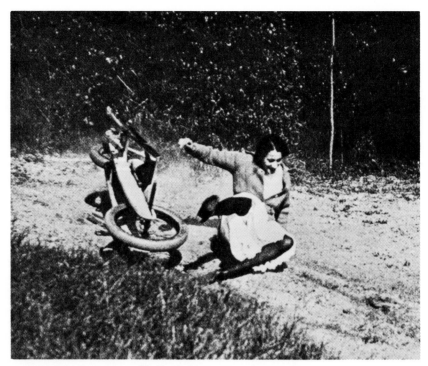

JACQUES-HENRI LARTIGUE: "Simone, the prettiest of them all."

and that, and that . . .' He would say yes, but wouldn't do it. Now I will do it. And I know that many, many things will ask to be photographed."

When he was nine, he stopped using his first 4.5 × 6 cm. plate camera, and at eleven he at last graduated to a Brownie No. 2, which was even easier to handle. Young Lartigue eagerly and unselfconsciously took pictures of everything that went on around him, particularly family scenes and happy moments of his life. Ignoring the conventions of the time, he took very few posed pictures or portraits, concentrating on what were really snapshots of the people close to him: Zissou, his brother; Yéyé, his aunt; Bichonnade, his cousin. Surrounded by the optimistic atmosphere of the upper middle class, he was right in the center of things and in close contact with the changing technology—he witnessed car races (his father owned one of the first Hispanos); the first light aircraft and the beginnings of aviation; the "lovelies" promenading in the Bois de Boulogne; the races at Auteuil; the winter sports at Saint Moritz; the first sea bathing at Biarritz and Etretat; Gaby Deslys at the Casino de Paris, and so on.

Every day he found something to marvel at—the First World War was one of the most interesting periods he was ever to experience—and he recorded this amazement faithfully in his diary, which was a real *aide-mémoire*. He intended the journal only for himself, but in 1962 it was made public by Charles Rado of the Rapho agency and by Richard Avedon. Its appearance in *Life* made Jacques-Henri Lartigue, despite his wishes to the contrary, a photographic wonder.

The liveliness of these photographs, shot on the spur of the moment, their easy-going way of looking at the world they embody, their free spirit, their rejection of the burden of technique, should not distract us from the sociological value of Lartigue's work. He faithfully portrayed the upper middle class's frenzied pursuit of happiness at any price, and its greed for novelty—this seemed to be the last fling of a social class that would lose many of its privileges after the First World War. As industry became more highly developed, the working classes began to acquire both an awareness of themselves as individuals and a combative spirit. The masses organized, strikes took place, women began to speak up. A new era was beginning.

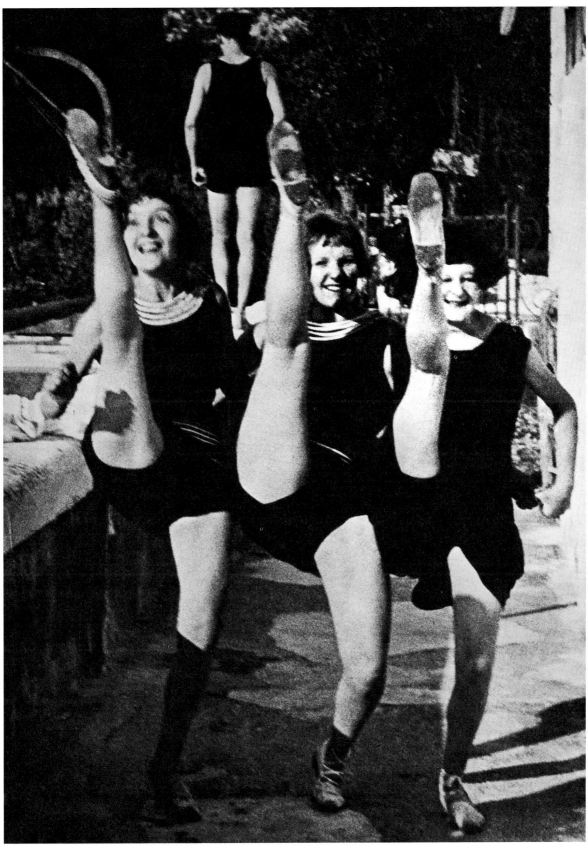

JACQUES-HENRI LARTIGUE

29

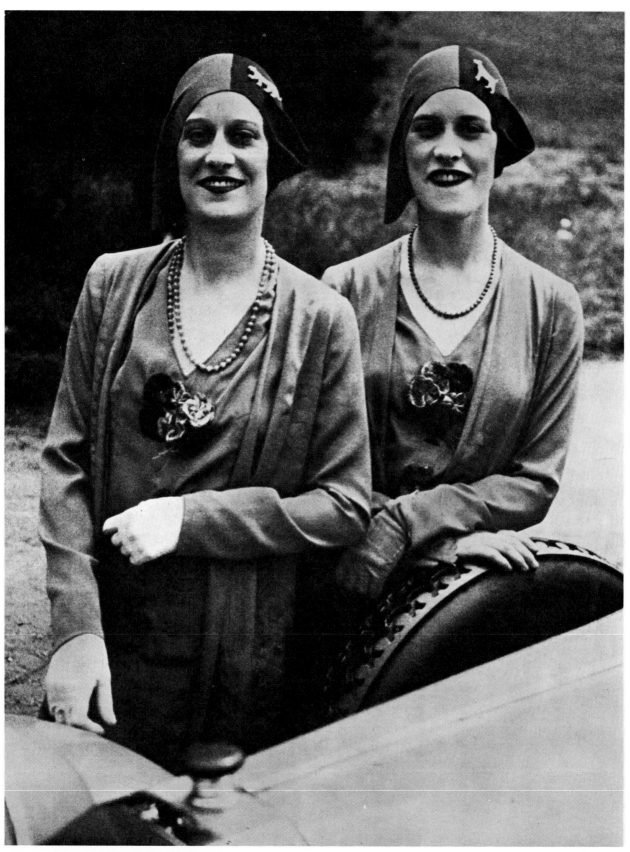

JACQUES-HENRI LARTIGUE, *The Famous Rowe Twins of the Casino de Paris*, Paris, 1929

GERMAINE KRULL

In 1905, Alfred Stieglitz and a group of friends opened the "291" gallery in New York, promoting photography as a legitimate art. By fighting traditional disciplines, Stieglitz wanted to stimulate the kind of experimentation that was going on with such enthusiasm in Paris. Paris was really in a fever of creative activity. Artists from all over the world arrived daily, attracted by the subversive magnetism of Montparnasse and the extraordinary people they might meet there. The Dadaists, then the Surrealists, were exploring the subconscious while giving it free rein. By looking at people and things with a fresh eye, they attempted to redefine reality, to rethink the meaning of life, to extend the limits of their technique. In 1921, Max Ernst exhibited his collages, in which he combined painted and photographed elements; André Breton saw in them the kind of new life that could overturn old values. In the exhibition catalogue he wrote: "The invention of photography has dealt a fatal blow to the old forms of expression in painting as well as in poetry, where automatic writing, which appeared at the end of the nineteenth century, is really a photograph of thought." From 1925 to 1939 photography actually served as a catalyst, a crystallizing element of all the different schools of graphic arts in Paris, a Paris that then more than ever deserved to be called "the city of light." All the important photographers passed through the city and gathered at the gallery-bookstore "La Pléiade" or at the Café du Dôme, some of them (Hungarians and Germans) fleeing Nazism, others pausing only long enough to absorb part of the creative excitement emanating from everyone involved in the visual arts.

The grand idea of the unity of the fine arts adopted by the Bauhaus had never before been put into practice as completely as it was at this time. The big illustrated newspapers launched in 1927, such as *Vu*, *Regard*, and especially *Arts et Métiers graphiques*, devoted an annual issue to photography, and the word "Paris" appeared in a good many of the credits. In 1934 Zuber and Boucher created the Photo-Alliance for the purpose of commercializing photographic illustration. Photojournalists, illustrators, fashion photographers, and collectors exchanged often contradictory ideas in an attempt to combine contemporary esthetics with social preoccupations. While Kertész, Robert Capa, Cartier-Bresson and others gave birth to the "new reportage," the real center of interest remained graphic research, the signature of light, reflection on the language of photography and its fusion with the other arts.

A considerable number of women were making their influence felt as photographers. For instance, Germaine Krull, while contributing to the largest news magazines, participated in literary works and experimented with multi-image photography; Florence Henri used mirrors and compositions made up of reflections to create self-portraits; Laure Albin-Guillot gained renown in photographic circles for her academic nudes; Nora Dumas excelled at news photography; Gisèle Freund became known for her portraits of famous writers, which were published in color in *Time*. She was also—in 1936—one of the first news photographers to have her work published in *Life*.

Prominent among the male photographers were Maurice Tabard, whose surrealistic superimpositions and solarizations, possibly preceded those of Man Ray; Pierre Boucher, a graphic artist and inventor of underwater cameras, a passionate innovator who went far beyond the established rules and who photographed his friends jumping in the air long before Halsman did; Emile Savitry, the on-set still photographer for the films of Jacques Prévert and Marcel Carné, was also well known for his superb nudes and for his photo essays in the humanistic style.

Three artists from abroad, Man Ray, Kertész, and Brassaï, came to Paris looking for the excitement necessary to their work and impregnated both French and international culture with their vision, shattering the limits of photography. Man Ray went beyond reality and reinvented photography. Kertész showed the stultifying aspects of everyday life and created modern photography; Brassaï gave expression to the fantastic side of society and the poetry of city nights.

MAN RAY (1890–1976)

"Man Ray is Man Ray, is Man Ray, is Man Ray . . ." This was Gertrude Stein's apt description of a man who was never bound by the artistic rules of his time, and whose fierce individualism and childlike sense of fun kept him from fitting into any definable style or preexisting discipline. He made original works out of everything that came to hand, and in his spontaneity endowed objects and techniques with new meanings by dissociating them from their primary, intentional functions. Whether in architecture, painting, drawing, photography, sculpture, the creation of metal objects, cinema, or writing, Man Ray was able to bend every technique to his overwhelmingly rich imagination and his total lack of inhibition.

He began taking photographs in New York in 1920, almost in spite of himself—he would never admit to being a photographer—because he wanted good reproductions of his paintings, and in 1921, having just arrived in Paris, he continued taking pictures as a way of earning his living. In a very short time he befriended the artists of Paris, many of whom were now caught up in the excitement of the Dadaist and Surrealist movements, and as their official photographer he became internationally famous.

While a number of ambitious young photographers—Stieglitz, Steichen, Weston—had already imposed strict rules on themselves, Man Ray attacked photography with a completely pure and liberating spirit. He started by settling the old dispute between photography and painting: "I photograph whatever I do not want to paint and I paint whatever I do not want to photograph . . . Speaking of painting, isn't it astonishing that a hundred years after the invention of photography, painters still persist in doing something which requires so much hard work and perseverance and could be done better and more quickly with a Kodak . . . A photograph is to a painting what an automobile is to a horse. A rider on his horse is a beautiful thing, but I prefer a man in an airplane." He took wicked pleasure in demystifying photographic technique, by taking apart his camera as though to give it a more human dimension: "We don't use our eyes in painting any more, so I've also done away with the eye of my camera—its lens." And what should be more natural than that Man Ray should reach the point where he could make photographs without using his camera at all! One evening, in his improvised darkroom in the rue Campagne-Première, he carelessly put some things down on the sensitized paper under the light of his enlarger, and to his great surprise he saw images form. Although the objects were recognizable—a key, a revolver, a pipe—what inter-

ested Man Ray was the juxtaposition of sharp and blurred lines, the gradation of tones, a chromatic scale of light rays and shadows which he baptized *rayography*. Some time after that, he accidentally turned on the light in his laboratory and noticed that a negative immersed in the developer was changing and creating luminous halos. Man Ray immediately saw the amazing possibilities of this technique, which he called *solarization*, and he used it to accentuate the contours of his nudes and portraits and to create an illusion of three-dimensionality.

Man Ray's work continued to influence not only a whole generation of photographers, and movements such as "subjective photography" and "photoform," but also modern art in general. Today, at a time when the definition of art is being questioned again and creative artists are using social and cultural symbols in their work, a statement Man Ray made in 1928 deserves to be repeated: "Is photography an art? There is no point in trying to find out if it is an art. Art is old-fashioned. We need something else."

ANDRÉ KERTÉSZ (1894–)

During the ten years he spent in Paris, André Kertész left his mark on French photography and influenced many photographers, including Cartier-Bresson, who said of him: "We all owe him something." The forcefulness and effectiveness of his way of looking at the world results from his visual discipline, which enables him to record the everyday sights of the city with unprecedented precision.

Born in Budapest in 1894, André Kertész bought his first camera, a 4.5 × 6 cm., in 1913. After photographing the war as an amateur and publishing his first pictures in the magazine *Erdekes*, he moved to Paris in 1925, attracted by the artistic life of the pe-

riod. From 1925 to 1928 he worked as a freelance photographer for a number of newspapers, including the *Frankfurter Illustrierte* and the London *Times*, which were beginning to give photography a prominent place in their pages. In 1928 he bought his first Leica, a camera invented by Oscar Barnack and marketed since 1925 by Ernst Leitz. The Leica already possessed all the features that would make it the best-known camera in the world: 24 × 36 mm. pictures, 36-picture capacity, easy loading, speed of operation, interchangeable lenses, etc. It was perfected just in time for a whole new generation of photographers who needed a camera as handy as a pen with which to capture the most fleeting moments of life, the most unexpected situations.

André Kertész used his new acquisition with intelligence and a certain sense of humor. Together with the very young Cartier-Bresson he contributed to the new publication *Vu*, which had been started by Lucien Vogel in 1928. He became more and more absorbed in his studies of the photographic surface, dividing it into forms that incorporated human elements.

His work with surface resulted in an important series of pictures of women, published in the magazine *Le Sourire* in the early thirties. The series was exhibited in Paris in 1932, creating a sensation. The "distortions" are "straight" photographs taken of distorting mirrors in which the naked bodies of one or several women are reflected. Created at the same time as Pablo Picasso's "Woman in Front of a Mirror," the series exalted the look of the thirties and foreshadowed Giacometti's work and Leslie Krims's Polaroid *fictcryptographs*.

In 1936, after the publication of *Paris vu par André Kertész*, with a text by Pierre Mac Orlan, Kertész moved to the United States. Except for a group of photographs of Washington Square, the work done there does not show the inspiration and creativity of his years in Paris.

BRASSAÏ (1899–)

Until he turned thirty, Brassaï had never even held a camera; photography was not something he thought about at all. He was born Gyula Halász in Transylvania in 1899. After fighting in the Austro-Hungarian army and spending some years in the extraordinary Berlin of the twenties, Brassaï arrived in Paris in 1924. Every week he would write a long, detailed letter to his parents describing the life of "Bohemian Paris" and the provocative ideas in the air. These "verbal moments," as he called them, did not satisfy his desire to convey his poetic vision of Paris, the marvelous images of the city in which he loved to stroll at night in the rain or fog. He thought of using photography to express what he felt. He borrowed a camera from a friend, and with some help from André Kertész began to devote himself completely to this new mode of expression.

Sometimes accompanied by Henry Miller, Raymond Queneau, or Jacques Prévert, but most often alone, he embarked on a true sociological investigation of the Paris underworld. He was interested in its extraordinary Dostoevskyan figures, and he was the first photographer ever to come so close to them. He did this at considerable risk to himself: it is not easy to enter this underworld, where distrust reigns and annoying onlookers are easily disposed of.

In these "journeys to the end of the night" we see for the first time what before was only literature— transvestites, hooligans, pimps, prostitutes from the rue Quincampoix, famous brothels, and also the whole picturesque side of Paris by night. In a similar spirit Jean Gabin began his series of roles portraying warm-hearted bad guys in 1936, and it is no coincidence that poetic realism reached its height with films like Duvivier's *Pépé le Moko*, Jean Renoir's *The Lower Depths*, and Marcel Carné's *Port of Shadows*.

When taking pictures at night, Brassaï used a tripod and set his camera for very long exposures. Street lamps, spotlights on buildings, and lighted signs shine on the street or in puddles of water to create a dramatic chiaroscuro, heightening the mystery of the figures photographed. The formal composition of his pictures seems just as important as its subject, producing a particular type of photograph in which the information it transmits—its documentation—has the timeless perfection of a painting. "Only vividly perceived pictures can penetrate deeply into the memory, remain there, become unforgettable. For me this is the only criterion for a beautiful photograph."

Notable among the works of Brassaï, who is also a painter, writer, and sculptor, are *Conversations with Picasso*, which he set down from memory; a series of photographs of graffiti revealing the social preoccupations of the time; and a collection of previously unpublished photographs entitled *The Secret Paris of the '30s*, which was published by Gallimard in 1976 (Pantheon Books, New York and Thames and Hudson, London, 1976).

GERMAINE KRULL

JEAN MORAL

JEAN MORAL

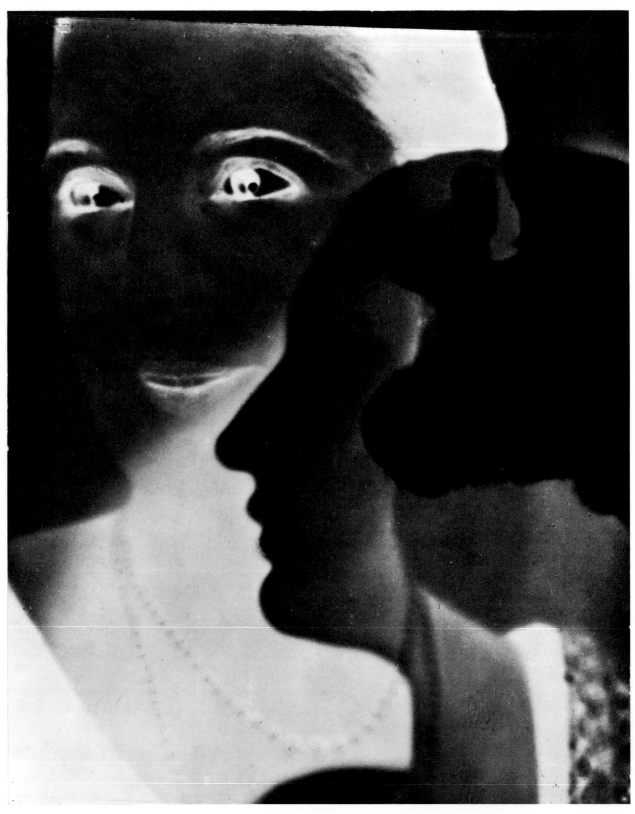

MAURICE TABARD

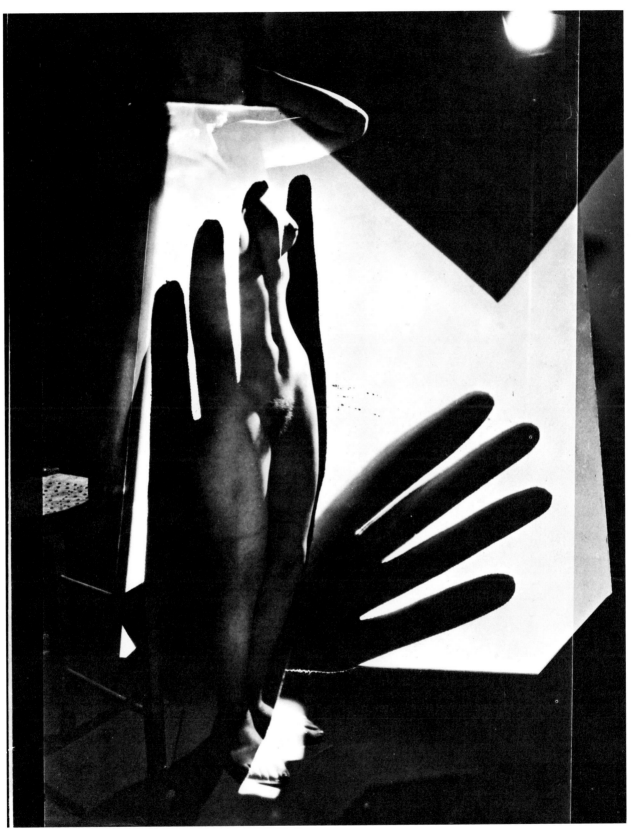

MAURICE TABARD

EMILE SAVITRY

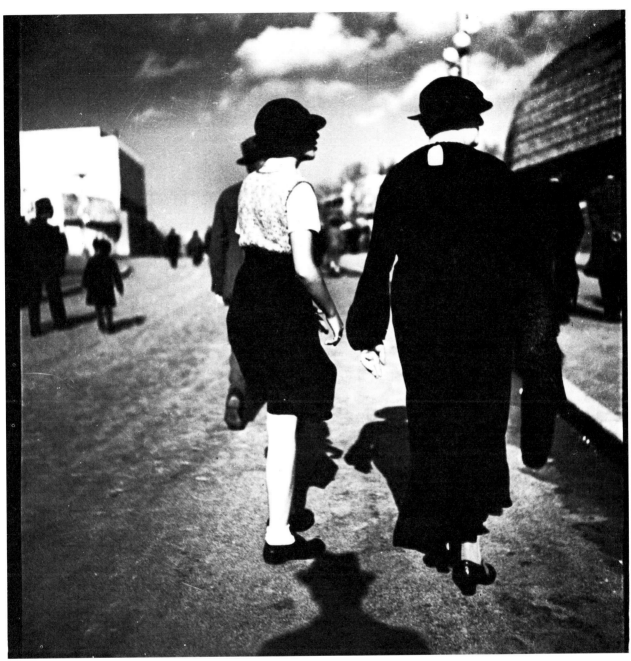

EMILE SAVITRY

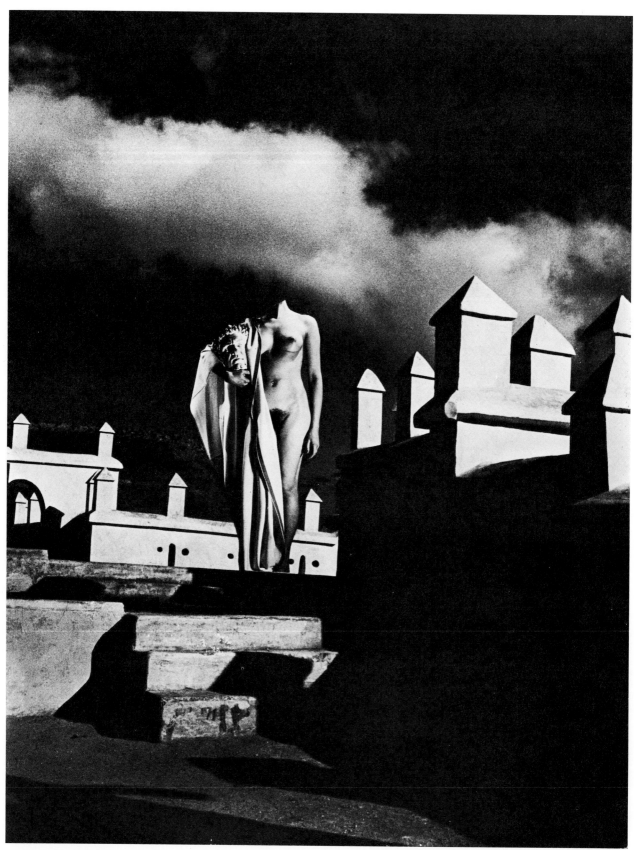

PIERRE BOUCHER, 1936

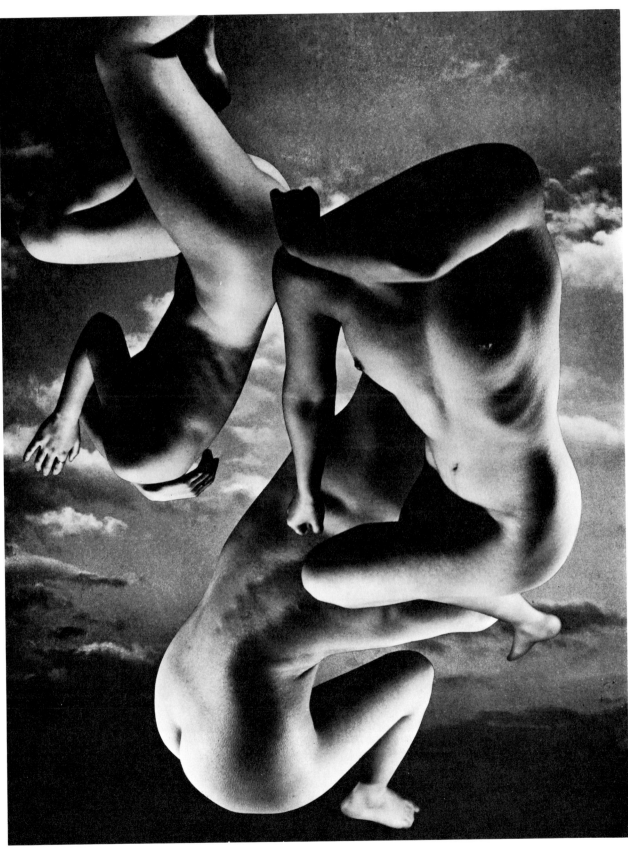

PIERRE BOUCHER, 1936

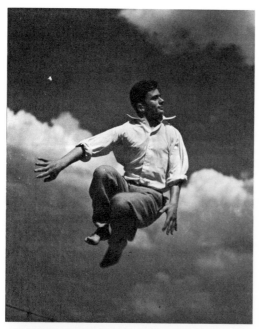

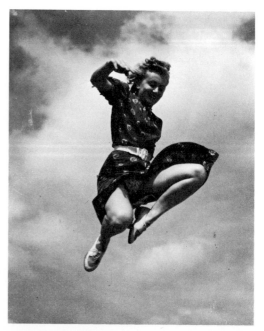

PIERRE BOUCHER, 1937

PIERRE BOUCHER, 1937

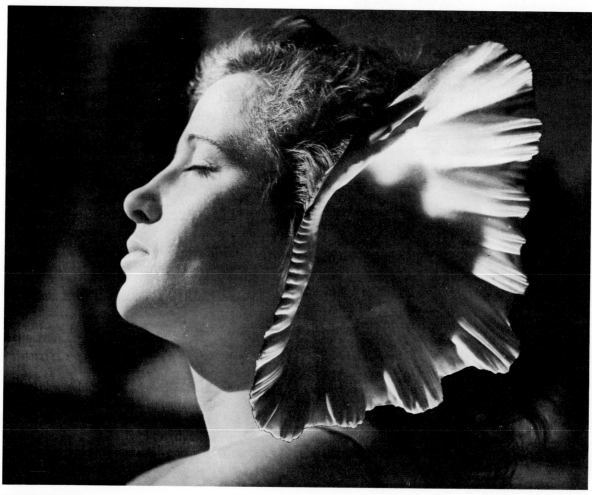

PIERRE BOUCHER

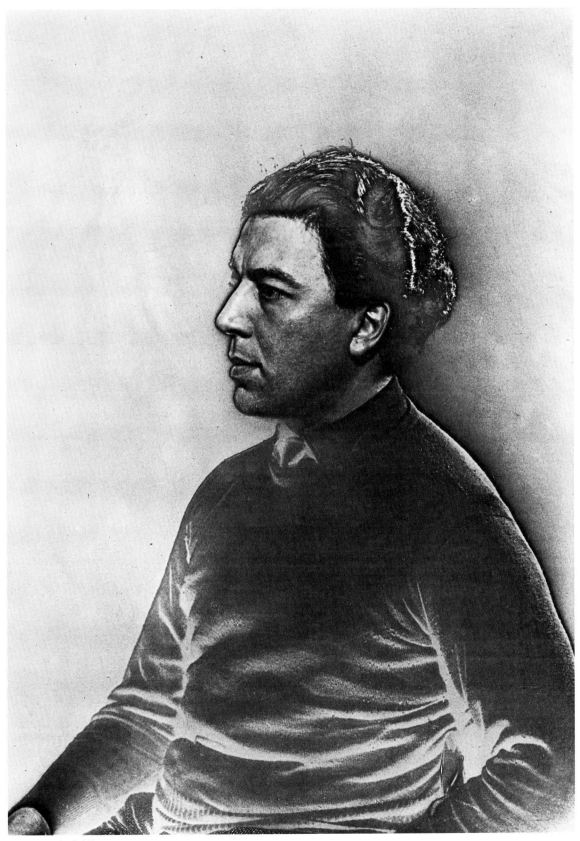

MAN RAY, *André Breton*, 1932

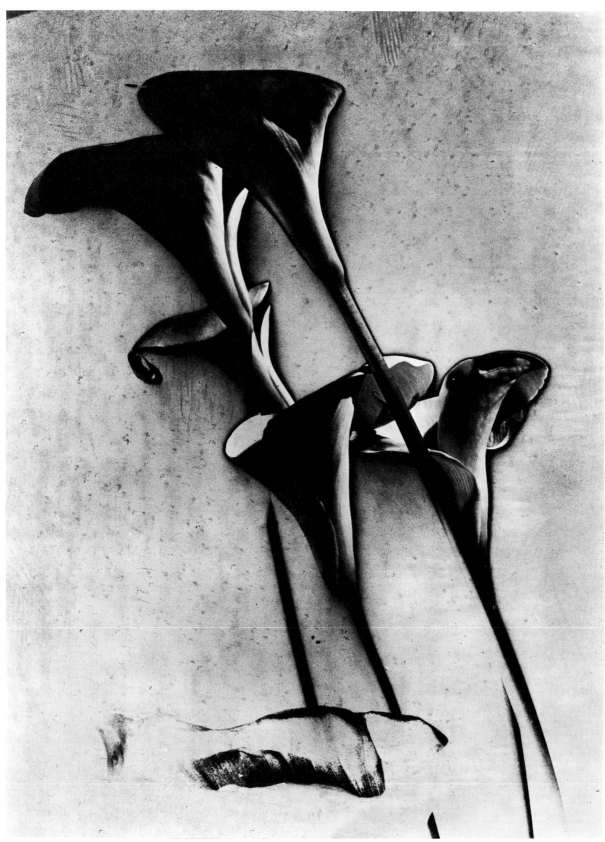

MAN RAY, *Solarization*, 1931

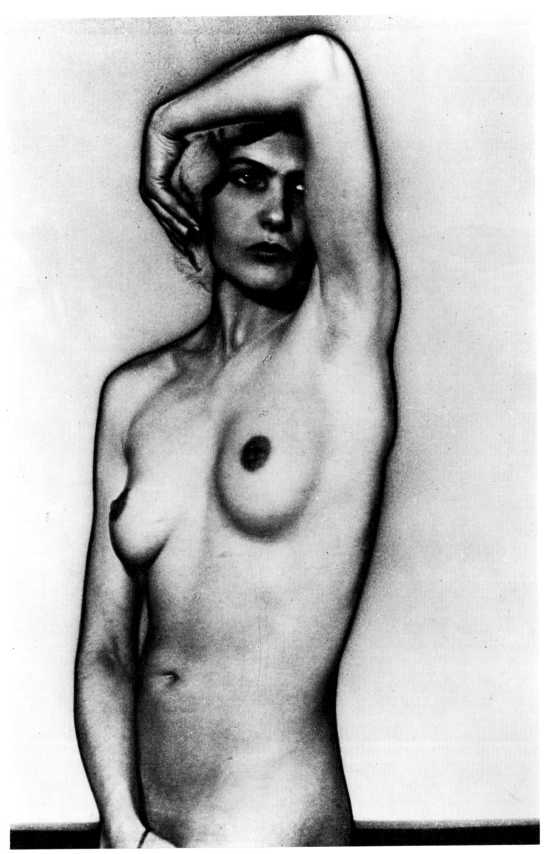

MAN RAY, *Solarization*, 1931

ANDRÉ KERTÉSZ, *Window*, Paris, 1928

ANDRÉ KERTÉSZ, *The Pont des Arts*, Paris, 1932

ANDRÉ KERTÉSZ, *Distortion "40,"* Paris, 1933

BRASSAÏ, *The Sun King*

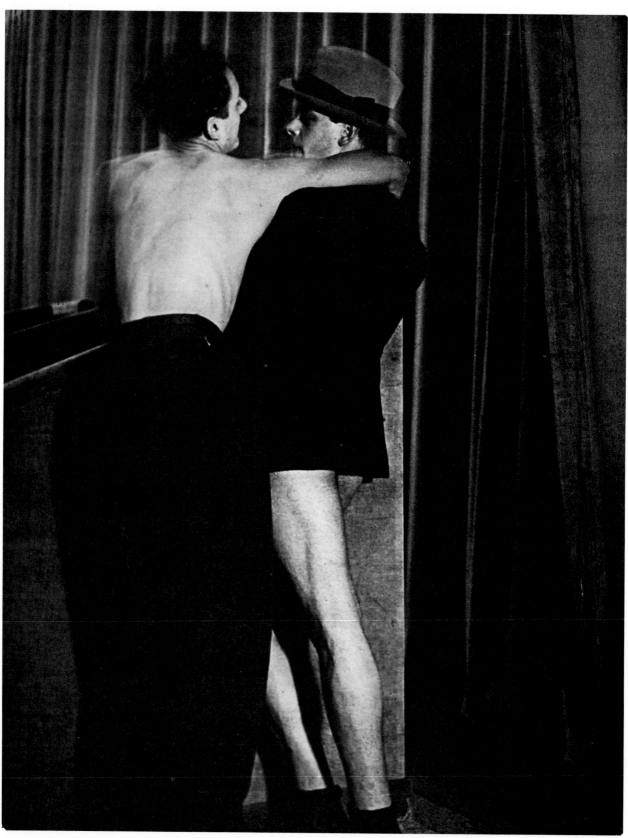

BRASSAÏ, *Young Couple*

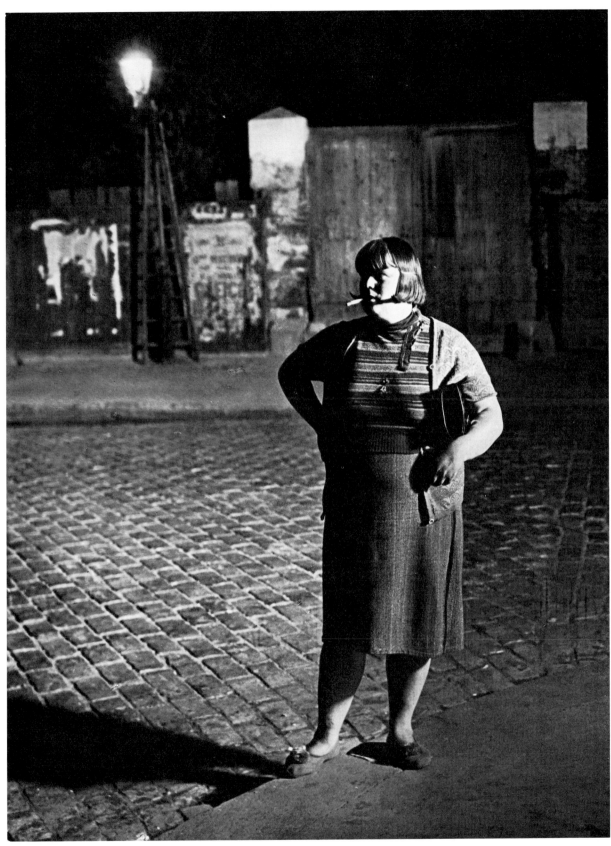

BRASSAÏ, *Prostitute, Italian Quarter*, 1932

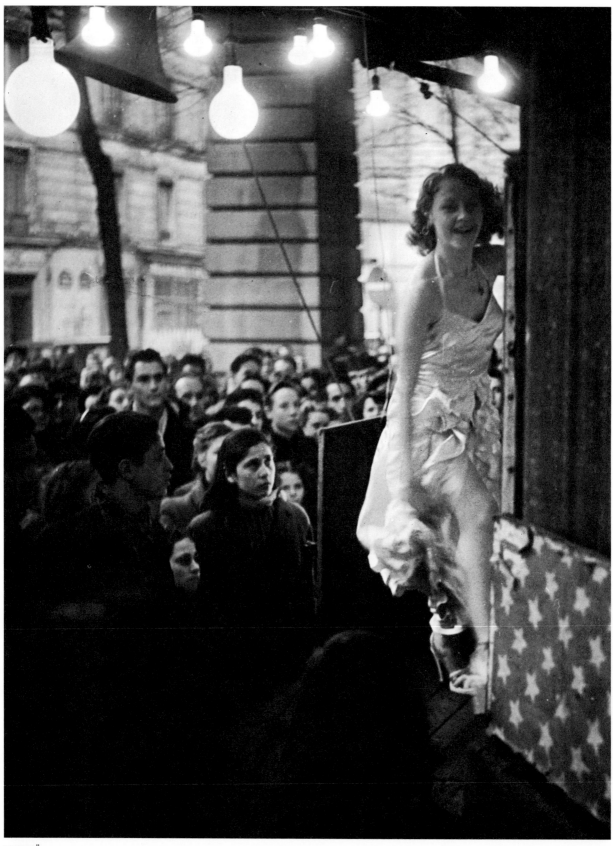

BRASSAÏ

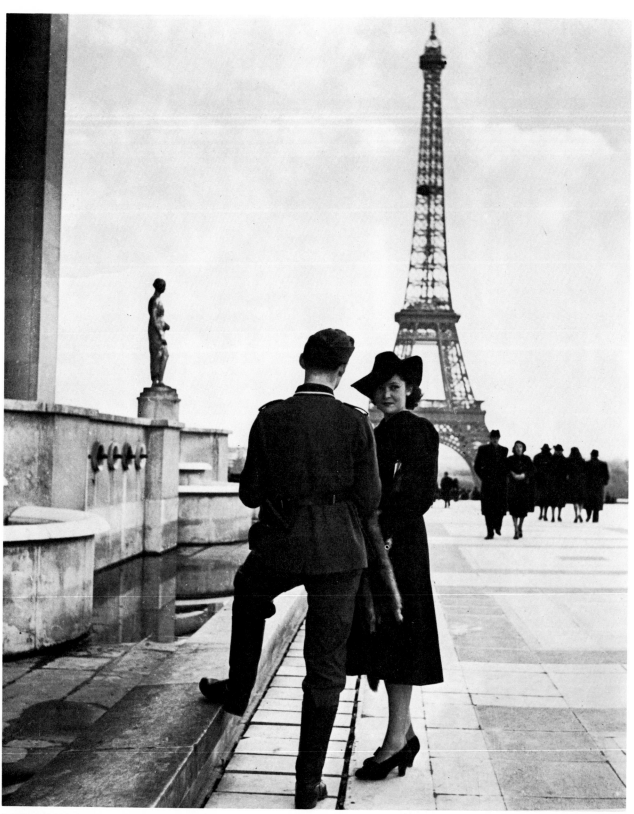

ROGER SCHALL, 1941

THE BIRTH OF A SENSE OF MISSION
(1930–1945)

In 1930, the world-wide economic crisis, the still-fresh memories of the horrors of World War I—which had been spread over the front pages of all the illustrated magazines—and the outrageous expense of the arms race increasingly led artists to become inwardly rebellious and turn toward realism. In the United States, photographers who had made a fortune from esthetic and more or less pictorial work became aware of their class privileges and as a sign of their new standards burned all their past work! In 1932, several admirers of Edward Weston, including Ansel Adams and Imogen Cunningham formed Group $f/64$, named after the smallest aperture in a camera which gives an absolutely sharp image. They swore to devote themselves to pure photography, whose only purpose would be the search for truth.

In 1935, the American government, well aware of the impact of photography, hired Roy Stryker as chief of the historical section of the New Deal Resettlement Administration, a catch-all for various agencies of the Department of Agriculture and the Department of the Interior. Stryker's mandate was to keep a record of whatever could become of historical interest in the future. Because of his long prior involvement with photography, though not a photographer himself, he turned to this medium as a means of documentation. The original group of photographers included Arthur Rothstein, Carl Mydans, Walker Evans, and Dorothea Lange. Ben Shahn, who helped Roy Stryker in various

capacities, though not officially employed by him, created some of the most telling documents of the period. It was during its first two years of existence that the RA, under Stryker, produced its most memorable photographs. These showed not only the plight of the displaced tenant farmers and agriculture in general, but also the problems facing small towns and cities. In 1937 the Resettlement Administration was subsumed into the Department of Agriculture, and its name changed to the Farm Security Administration. Before its demise in 1943, when the photographic files were transferred to the Library of Congress, the FSA's staff included such now-well-known photographers as Gordon Parks, Russell Lee, and John Vachon, among others. It produced 130,000 pictures, which included some of the early documents showing the United States' preparation for World War II.

On November 23, 1936, Henry Luce, publisher of *Time* magazine, brought out the first issue of *Life*; its cover was a photograph by Margaret Bourke-White of the construction of a dam. This magazine, too, seemed to answer a need for realism, an urgent desire to communicate through photography: "To see life, to see the world, to witness great events, to examine the faces of the poor, the behavior of the pretentious . . ."

As for the French, they were full of optimism in 1930, and managed to believe that what was happening in other places did not concern them. Paris wel-

comed artists from all over the world, retreated into the pleasures of the night and reveled in its own intellectual excitement. Meanwhile, the economic crisis was ravaging Germany, where hundreds of thousands of unemployed helped Hitler rise to power. In 1932 the crisis hit France. Ministers succeeded one another at a dizzying pace, a general feeling of exasperation grew, and people who wanted to reconcile Leftist ideas with Fascist efficiency fell under the sway of Mussolini. The first large demonstration by the Popular Front took place on January 18, 1935, when socialists, Communists, trade unionists and Leftist radicals rallied around the slogan "Bread, peace and liberty." They were not only seeking satisfaction for the demands of the underprivileged classes, but also trying to create a "new humanism" based on the liberation of the workers and the right of everyone to his own culture. Illustrated magazines flourished, displaying pictures of the people's fervor, factory workers, festivals and scenes from daily life. This period marked the beginning of the photographic careers of Doisneau, Ronis, Izis, and Cartier-Bresson (who photographed people taking their first paid vacations) and many others. Each in his own way exalted the lyrical side of life and identified with the subjects he photographed.

In 1936 the Spanish Civil War broke out. Chartered groups were organized to fight Franco alongside the Republicans. Photographers from all over the world flocked to Spain, taking the opportunity to test new equipment, from Leicas to Rolleiflexes 6 × 6 cm., which were easy to handle, of very high quality, and convenient to use under all kinds of conditions. The magazine *Vu* published Robert Capa's photograph of a Spanish militiaman being shot down as he ran forward, and in 1936 devoted a special issue to the Spanish Civil War. Long before *Life, Vu* had made photography its main feature and had developed the "picture story," which allowed photographers to develop their themes in full. The magazine's Swiss owners, however, did not like Lucien Vogel's sympathy with the Popular Front and forced him to resign. This was the death warrant of *Vu*, and it disappeared from the publishing scene.

The Popular Front ended in 1938 in an atmosphere of general bitterness, and a year later World War II broke out. The Nazis controlled the media during the Occupation, although they allowed the French to continue working as editors so that the publications would retain some vestige of credibility. Even armed with passes, photographers found it difficult to take pictures outdoors without the collaboration of the occupying force. The magazine *Match* was taken over by the Nazis, who transformed it into a propaganda tool; under the new name of *Signal*, it became a large-format luxury picture magazine. Most amateurs and photographers without press cards were reduced to photographing still lifes and nudes, while some joined the photographic and cinematographic services of the armies. The main editorial staffs of the illustrated magazines fled to unoccupied France; *Vogue*, which at that time had its offices on the Champs Elysées, lost all its prominent contributors, including Cecil Beaton, Horst, and Durst.

On November 28, 1944, Raymond Schall published a book conceived during the German occupation. It was sold out within a few days. Entitled *À Paris sous la botte des nazis (Paris Under the Boot of the Nazis)*, it is a horrifying diatribe dramatically combining a text by Jean Eparvient and powerful photographs by Roger Schall, the Seeberger brothers, Vals, and Jarnoux. Some of the pictures, which reveal how terrible daily life was for Parisians during the Occupation, were used as evidence in court to satisfy the inexorable thirst for revenge that inevitably follows the end of any war.

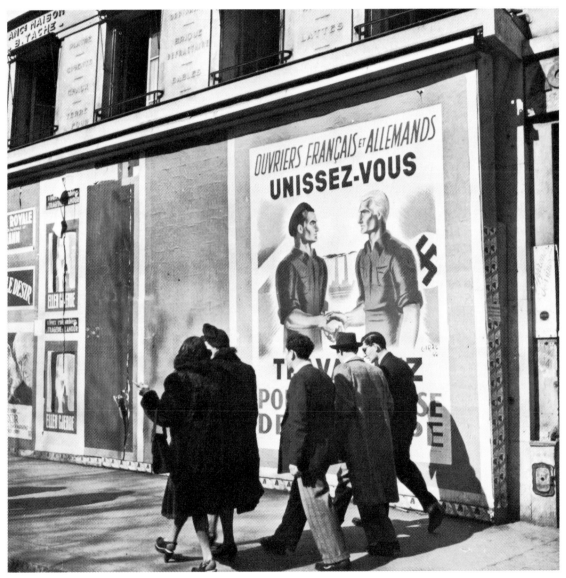

ROGER SCHALL, 1941-42

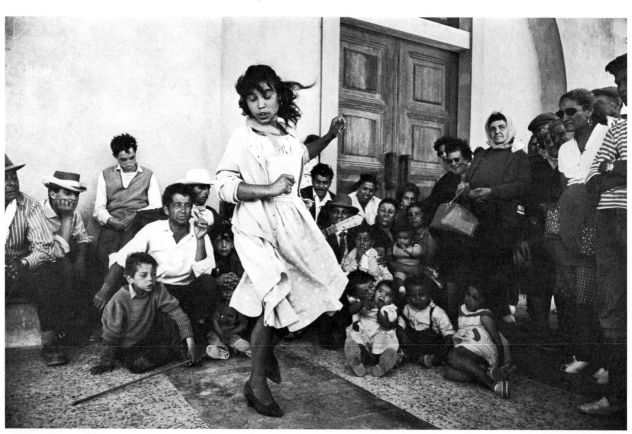

SABINE WEISS, 1968

62

After enduring years filled with the restrictions and horrors of war, the country began rebuilding economically and psychologically. The French people needed to forget the thousands of terrible pictures they had seen in magazines and newsreels. They were beginning once more to believe in the great humanitarian values, and they wanted to make their peace, to work together to create a new life. The illustrated papers and magazines flourished, taking part in the reconstruction of the country by printing the pictures that the people demanded, pictures they could now identify with.

These picture stories portrayed fragments of daily life filled with simple emotions and pleasures—weddings in a bus in Nogent, bistros, bicycle excursions, country fairs, lovers, children playing in the Mediterranean sun. Jacques Prévert conveyed the mood of the time, which fell somewhere between realism and romanticism: love of life was expressed by the desire for simple things and simple experiences—rain and sunshine, the great rite of spring. It was quite natural that he should write the prefaces to several books by photographers who were his friends—Boubat, Izis and especially Doisneau.

In 1955 Kodak developed a new emulsion, Tri-X film. Because of its fast rating, photographers could take more indoor pictures, and the light in their pictures had the same intensity as the light they saw through their own eyes. For example, in the photographs of Sabine Weiss, a freelance photographer who worked for the Rapho agency and magazines like *Vogue, Life* and *Holiday*, the light shines through in all its subtlety, filling ordinary scenes of everyday life with an intimate warmth.

The four most influential photographers who worked in this field of humanistic reportage and whose photographs appeared in the important magazines of the time—the resurrected *Paris-Match, Réalités*, and so on—were Robert Doisneau, Izis, Ronis and Boubat. Each in his own way was able to express uniquely photographic situations that could be understood without reference to any other form of expression. They created pictures that were self-explanatory, that needed no text in order to be experienced.

ROBERT DOISNEAU (1912–)

Robert Doisneau took his first pictures in 1930, after leaving the Ecole Estienne, where between the ages of fourteen and eighteen, he had studied engraving. Like children, whose vision of the world is fragmentary, and like a good many beginning photographers, he focused on details of objects and pieces of city trash, such as bedsprings, and tin cans, before broadening his vision of the world enough to dare lift his eyes and look at houses and people.

Under the influence of Vigneau, one of the important figures of the time, he freed himself from the inhibiting meticulousness of the Ecole Estienne and let himself be guided by his own instincts. In fact, he did this every time he felt burdened by his commercial work—even though it allowed him to enter places that were foreign to him and satisfy his curiosity about them. He took industrial pictures of the Renault factory from 1934 to 1939, and from 1948 to 1951 worked for *Vogue*, moving, against his own inclinations, in high society as he photographed barons and

baronesses. "I've always behaved this way. When I can't stand the work I do for a living any more, I go off somewhere for two, three, four days, a week. Not very far away. Exotic places and great distances are often a sign of impotence. When I explode, I just go to Paris or the suburbs. In Montrouge, in a humdrum setting not very far from where I live, I can at last take my time, spend it the way I want to: looking at things and people that don't seem very intersting but who reveal their burden of emotions, their pity or foolishness, if you look at them closely enough. I go off without any preconceived ideas, without any theme in mind. I let myself be guided by what I come across . . ."

With a sense of playfulness Robert Doisneau photographed the world in which he felt happy, in which the streets belonged to the people, the bistros had a festive air and different social classes mingled. Beginning in 1950, the working classes had been shunted into concrete towers a few miles away from Paris where they ran into one another only in the distressing confusion of the subway or the existential void of the supermarkets. Little by little, human beings were disappearing from the scene and Robert Doisneau, while accepting the nostalgia of his pictures, continued to capture moments when people overturned the established order and quite involuntarily broke free from the grasp of technology. These pictures contain a certain brand of humor, at times depicting comic situations that remind one of Chaplin's *Modern Times* or Jacques Tati's *Monsieur Hulot's Holiday*. And in fact Doisneau did take an extremely funny series of pictures of his friend, the cellist Maurice Baquet. Today many young photographers identify with the philosophic attitude Robert Doisneau embodied at a time when there seemed to be an increasing separation between artists and the public, when sensational and bloody pictures were splashed across the front pages of the newspapers. "You have to keep from being voyeuristic. You must not trample on other people's secret gardens. You must remember: to suggest is to create, to describe is to destroy."

Among his twenty or so published books are *La Banlieue de Paris* (*The Suburbs of Paris*), with Blaise Cendrars, *Les Parisiens tels qu'ils sont* (*Parisians as They Are*), *Instantanés de Paris* (*Snapshots of Paris*), and *La Loire*, which was published in 1978 by Denoël-Filipacchi.

IZIS (1911–)

Izis, whose real name is Israel Biderman, was born in Mariampolé, in Lithuania, on January 17, 1911. In 1930 he went to Paris to work as a photograp28, started his own business, and when the war broke out fled to the Limousin, where he earned his living retouching photographs for local photographers. In 1949 he joined the staff of *Paris-Match*, which was trying to become the French equivalent of *Life*, and worked on numerous stories for the magazine until 1969. What really fascinated Izis was Paris. Everything about the city enchanted and amazed him and when he returned from his professional trips abroad he would walk the streets taking childlike pleasure in what he saw: lovers embracing in broad daylight, statues that seemed alive, the poetry of the circus, kids playing in a park, flower-selling on the streets, wooden merry-go-round horses, and so on.

The truly original part of Izis's work is to be found in his books; they crystallize everything he has done. He designed the layouts himself, organized the sequence of pictures, and wrote his own commentary. He planned each book the same way: on the left-hand page a text, preferably hand-written by a poet, and on the right-hand page, a photograph. Jacques Prévert collaborated with Izis on five books: *Paris des rêves* (*Paris of Dreams*) in 1950; *Grand bal de printemps* (*The Great Dance of Spring*) in 1951; *Charmes de Londres* (*The Charms of London*) in 1952; *Le Cirque d'Izis* (*Izis's Circus*) in 1965, and *Paris des poètes* (*Paris of the Poets*) in 1977.

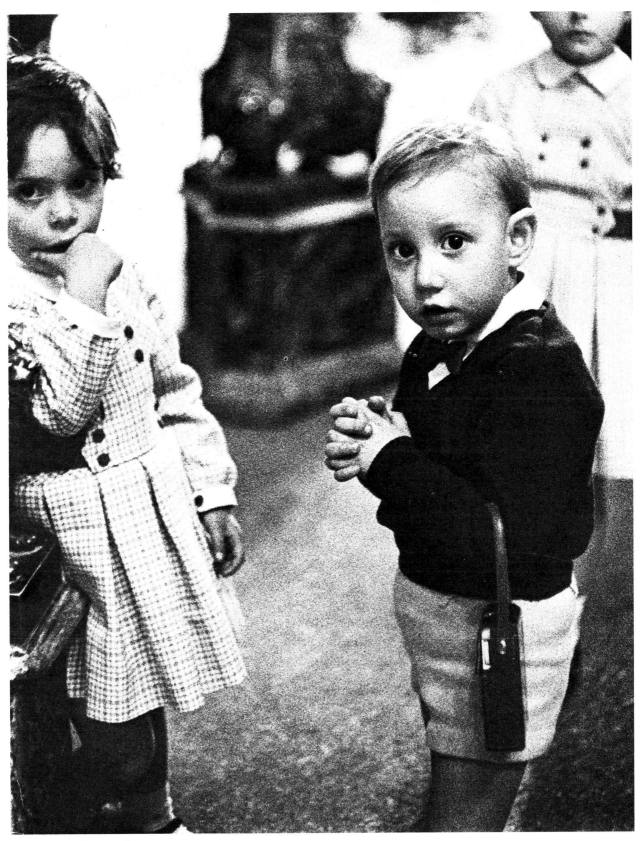

SABINE WEISS, *Rome,* 1964

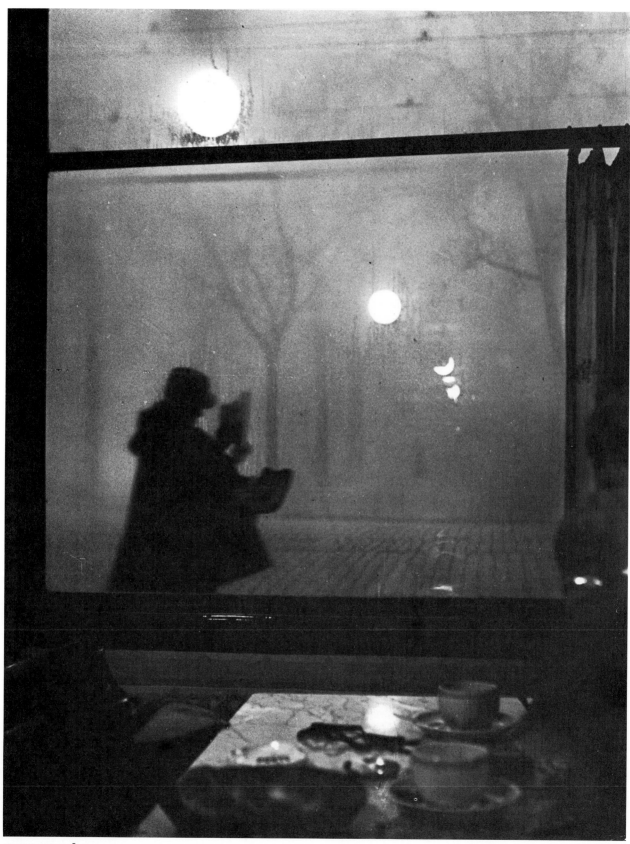

SABINE WEISS, *Lyon*, 1951

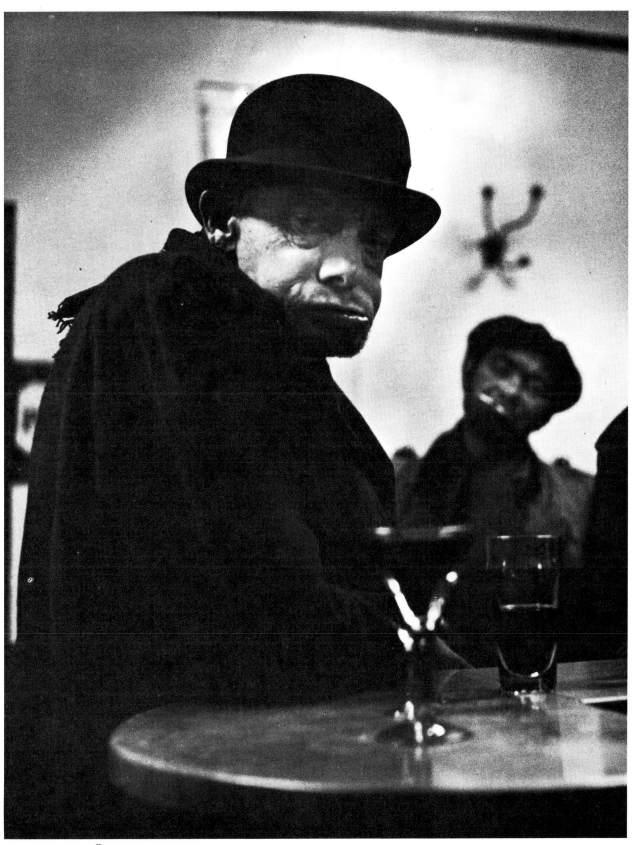

ROBERT DOISNEAU, *Coco*, 1952

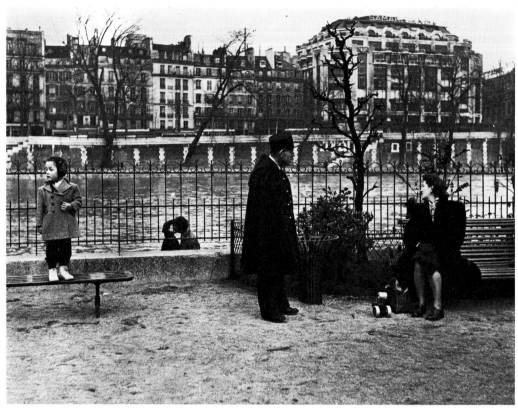

ROBERT DOISNEAU, *The Gallant*, 1950

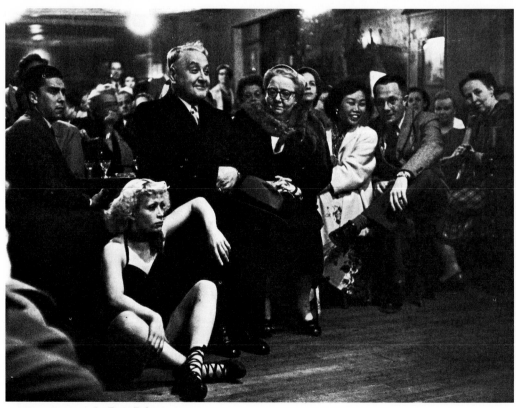

ROBERT DOISNEAU, *Le Petit Balcon*, 1953

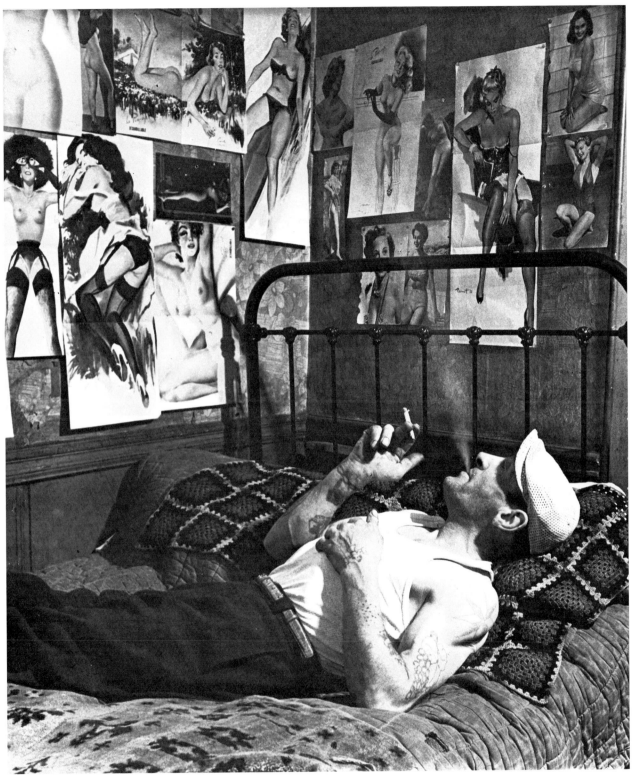

ROBERT DOISNEAU, *Creatures of Fantasy*, 1952

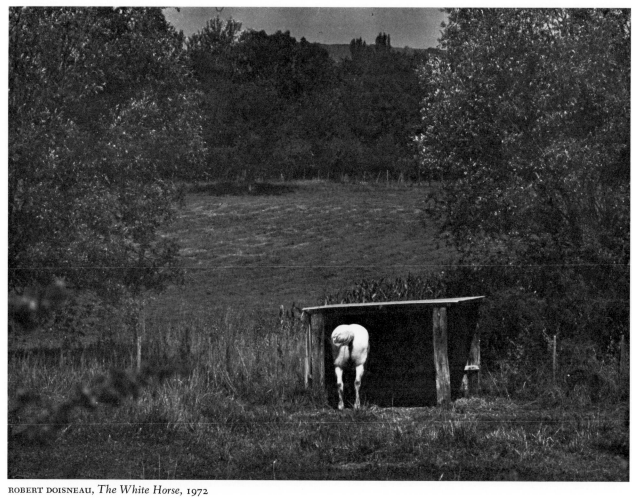

ROBERT DOISNEAU, *The White Horse*, 1972

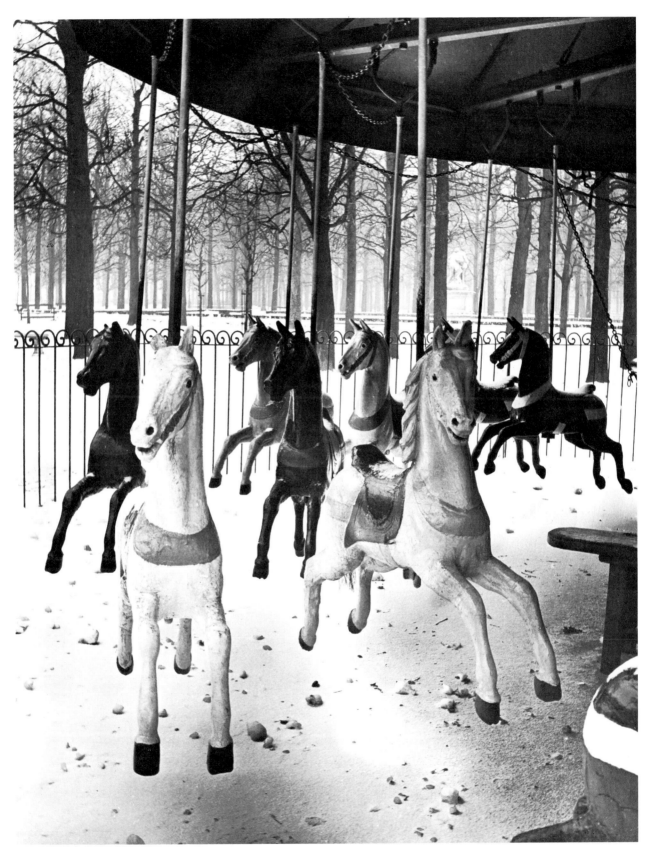

IZIS, *The Tuileries*, 1949

IZIS, *Trône Fair*, 1960

IZIS, *Canal, quai de l'Arsenal,* 1965

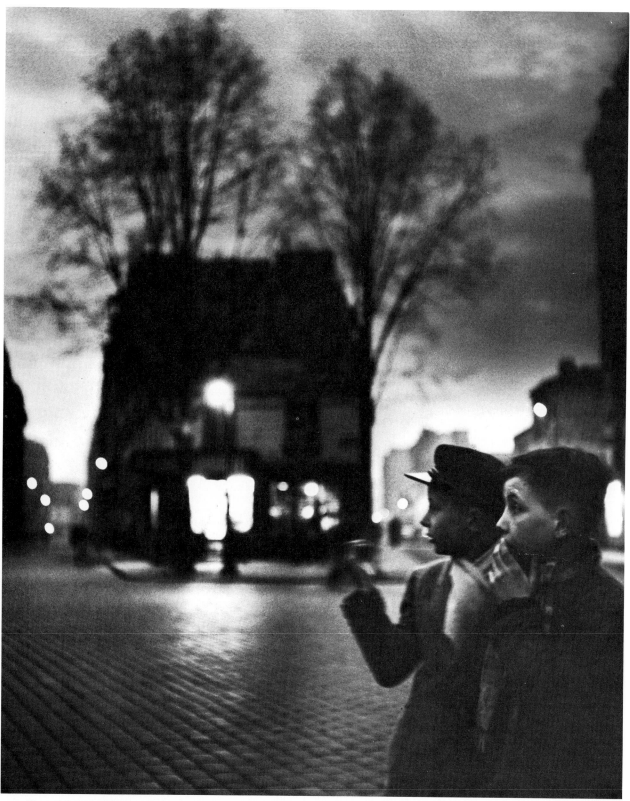

IZIS, *Place Falguière*, Paris, 1946

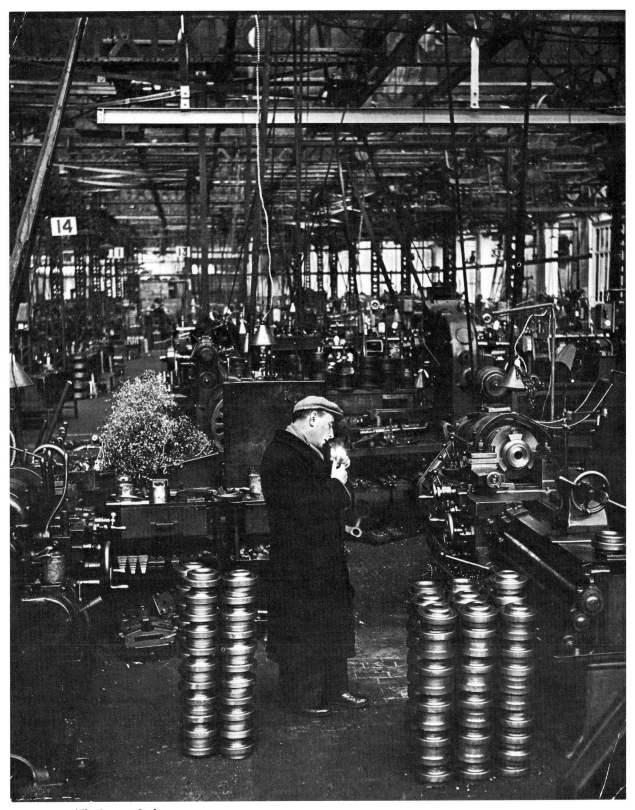

WILLY RONIS, *The Snecma Strike*, 1947

WILLY RONIS, Photograph used in Steichen's exhibition "The Family of Man," 1952

WILLY RONIS, *Provençal Nude*

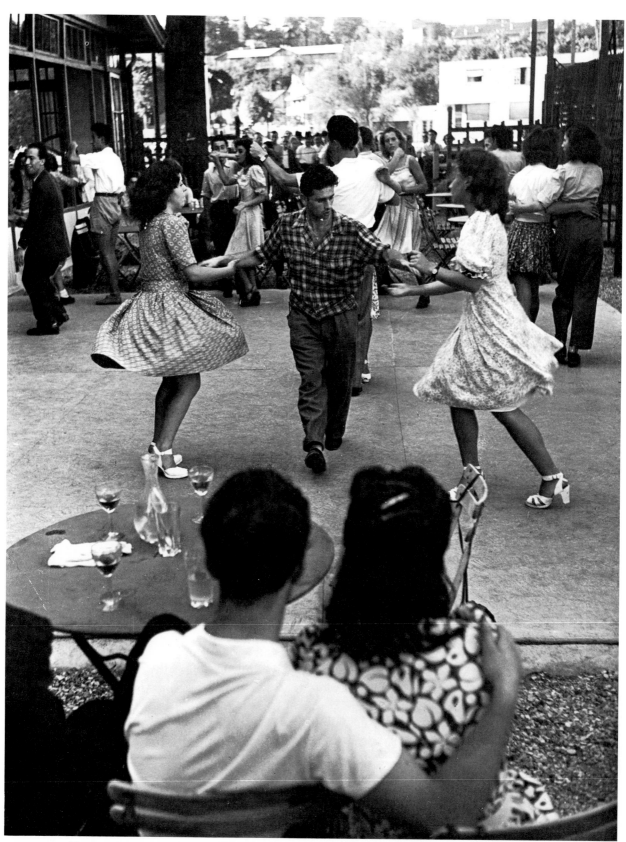

WILLY RONIS, *Nogent*, 1947

WILLY RONIS (1910–)

During this heyday of reportage, art directors were anxious to reach their readers through illustrations which, while presenting information, stirred people's compassion. Willy Ronis was undoubtedly the best representative of this trend, because not only was he able to illustrate a situation with a single photograph, but he could also infuse it with his inner feelings and his political convictions.

Ronis was born in Paris in 1910. His mother was a piano teacher; his father was a store-front photographer who loved *bel canto*. Willy Ronis imbued his pictures with his passion for music, whose structure can be likened to the rigorous composition of a photograph. His most ordinary subjects were enriched and enhanced by light, one of the most important elements in his pictures. A professional photographer from 1945 on, with a deep interest in social problems, Willy Ronis joined Doisneau, Brassaï, Savitry, and others at the Rapho agency. He was the first French photographer to work for *Life,* which he soon left for ideological reasons (he was not allowed to write the captions for his pictures). At present living in retirement in the south of France, he continues to work as an illustrator and teaches photography at the Avignon Beaux-Arts School and at the University of Aix-en-Provence.

EDOUARD BOUBAT (1923–)

Edouard Boubat, born in Paris, began his career as a professional photographer in 1951 after showing his work in an exhibition at "La Hune" bookstore-gallery along with Brassaï, Izis, Doisneau and Fachetti. Bertie Giloux, the art director of *Réalités,* invited him to join the staff as a news photographer. Until 1967, Edouard Boubat traveled all over the world on assignments for *Réalités;* he was particularly interested in photographing people in their own social environment, performing their primitive and religious rituals, working at crafts that revealed their pride of accomplishment. The highly formal quality and the careful composition of his photographs are striking; there is a special pictorial feeling about them and an almost musical rigorousness. Boubat seems to be able to organize the apparent chaos of reality into harmonious compositions which place mankind in the context of age-old history.

He excels at photographing women, and he photographs them not just to capture their eternal beauty but more especially to portray them during their contemplative moments or as they perform their daily tasks.

Since 1967, Edouard Boubat has been working as a freelance photographer and has published four important books: *Femmes (Women), Miroirs (Mirrors)*—portraits of writers—*Anges (Angels),* and *La Photographie* (a collection of articles).

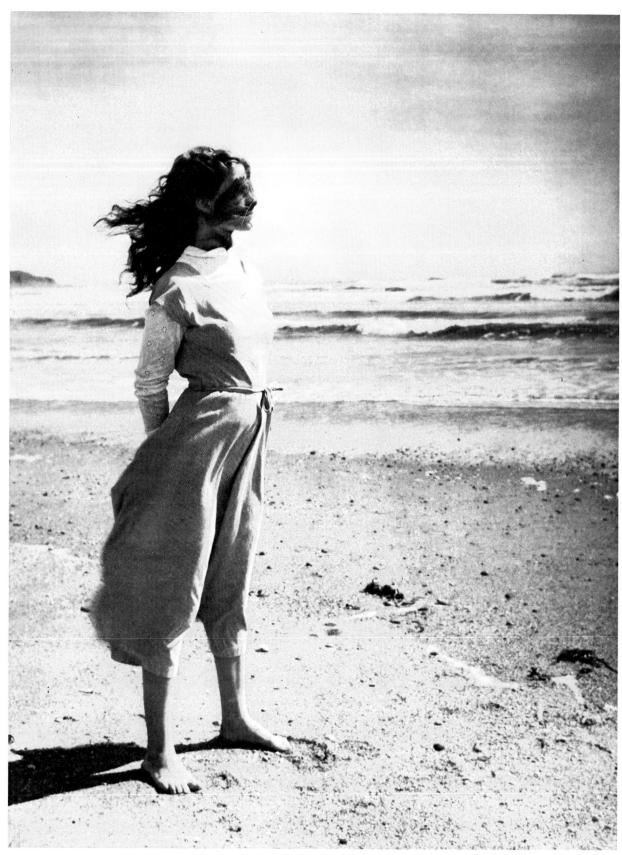

EDOUARD BOUBAT, *Brittany*, 1949

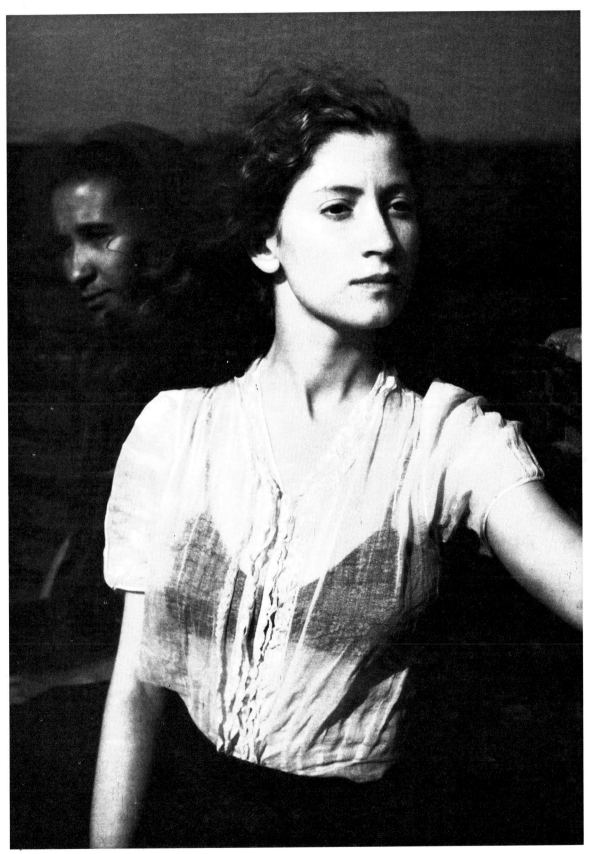

EDOUARD BOUBAT

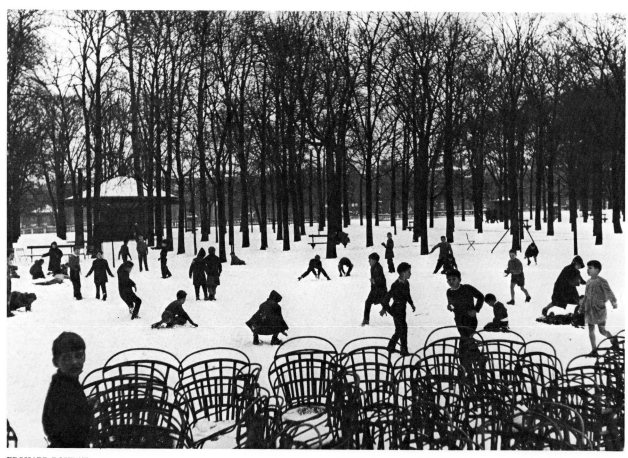

EDOUARD BOUBAT

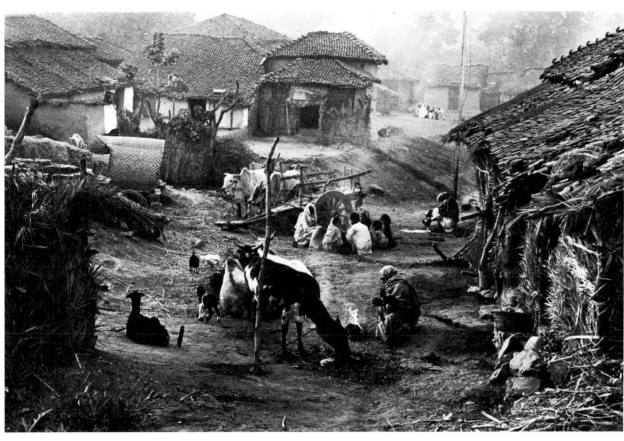

EDOUARD BOUBAT

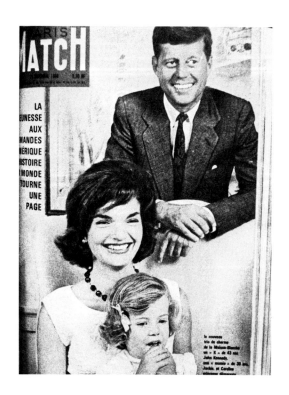

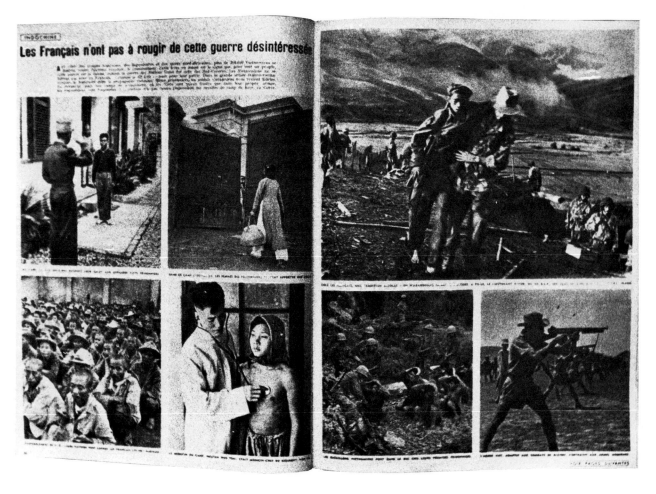

Between 1936, when *Life* magazine was started in the United States, and 1947, when the Magnum agency legally came into existence, modern photojournalism established the moral and philosophical profile of a new breed of photographers who traveled the world over, fascinating and attracting increasing numbers of enthusiasts. A photo-journalist is not only a photographer drawing on all his technical skill with each click of the camera, but also a reporter with his own ideas and convictions who has to analyze the facts he is dealing with before he can inform the public.

During the fifties and sixties photographs were published almost exclusively in the newspapers and illustrated magazines as examples of the kinds of things that were going on, as fragments of real life. They were, in fact, a very real part of the economic reconstruction of a world just beginning to recover from the horrors of the last war. The fact is that photojournalism answered a worldwide need for a kind of international humanism that had been neglected in the many exchanges and displacements of populations occurring during the war; it also fulfilled a desire for the clarification of certain political and social issues. A photograph was not seen as a mere photograph but as an entity involved with written language and defined in relation to it. What was more, the written word gradually took precedence over the photograph, and it was this fact that contributed to the hard times illustrated magazines went through around 1970 and which led to their eventual disappearance.

Photojournalism was first introduced in France by magazines like *Réalités* and *Paris-Match*—which was dazzled by the American press—by the Magnum agency, which turned photojournalism into a legend and a quasi-aristocratic sect, and finally by one man, Henri Cartier-Bresson, whose artistic, moral and philosophical qualities influenced the language of photography during the most prestigious period of reportage and continue to influence it today.

PARIS-MATCH

Match reappeared in France as *Paris-Match* on March 25, 1949. The editors secretly hoped that the high quality of its photographs and text would equal those of its rival *Life*, which was the model for the genre. Yet *Life* never had a rival, and the dream of French reporters was still to work for *Life*, to participate in "the greatest theater in the world"—even if it was frankly imperialist and anti-French—and to be able to add their names to the prestigious list that included Margaret Bourke-White, Robert Capa, George Rodger, Eugene Smith and many others. In *Life*, as in *Paris-Match*, there were two types of reportage: news subjects often furnished by agencies, and picture stories accompanied by texts on themes chosen by the editorial staff (tourism and folklore, charming or bizarre sights, scandals, famous people), often pervaded by a rather primitive kind of liberal humanism. Photography always had a prominent place, even if it was not until the sixties that pictures began to be regularly credited. Great events were reported weekly in the magazines, combined according to a subtle logic: the increase in cancer, the war in Indochina and Korea, the conquest of Everest, the engagement of Princess

Margaret to the photographer Anthony Armstrong-Jones, the Algerian war, the newest car models, the French atomic bomb, Yves Montand's affair with Marilyn Monroe, and so on.

Paris-Match had its own staff, which included Willy Rizzo, Pierre Vals, Izis, Maurice Jarnoux, Filipacchi (who twenty-five years later founded his own newspaper empire and bought *Paris-Match*), Jack Garofalo, Michel Descamps, Roger Thérond and Walter Carone.

Most of the photographs were taken with a 6 × 6 cm. (2¼ × 2¼) camera, using one or more electronic flashes to obtain as sharp an image as possible, one that would be easy to reproduce. The 35mm size gave pictures a more natural look, and gradually replaced the larger format.

RÉALITÉS

What the magazine *Réalités* set out to do was to take its readers on trips to exotic countries. This was the beginning of the sixties, when the "Club Méditerrannée" did not yet exist and when Jack Kerouac was writing about "the thirst for the road," escape from the madness and the nightmare of large metropolises. The magazine's permanent staff consisted of Edouard Boubat, Michel Desjardins, Jean-Philippe Charbonnier, and Jean-Louis Swiners, but the editors regularly solicited work from outside photographers, including Gilles Ehrmann, Jean-Pierre Sudre, and Frank Horvat. Working closely with the editorial staff, each photographer would create his own reportage, often in previously unexplored countries, and undertake an enormous amount of technical preparation on site before beginning to take pictures. Through the photographs, which were superbly reproduced in black and white and in color, and which conformed to very precise esthetic and ideological rules, the photographers were able to express their own vision of the world around them. However, after the magazine was bought ·by the Hachette group—and especially since 1965—*Réalités*'s new management has shown itself more and more often to be ignorant of the language of photography and has gradually stopped publishing socially relevant subjects, photographic essays, and the kind of large-scale, "free" reportage whose independent approach established the magazine's reputation and made its fortune. Its emphasis is now on folklore and the enchantment of certain places in the world, so that it has become a promoter of the modern tourist industry and group trips—which will eventually lead to its decline.

Jean-Philippe Charbonnier, born in Paris in 1921, worked as a layout man at *Libération* and *France-Dimanche*, and then as a reporter paid by the line at *Point de Vue*, with Albert Plecy, before joining *Réalités* in 1950. His career strikingly demonstrates the evolution of a reporter (a globe-trotter) into someone who has chosen to interest himself in the daily life of the people in his neighborhood—which he has done since 1975. When he shows his pictures in exhibitions, he wants them to be looked at not only as reflections of reality, but as fragments of his inner world, spaces to be questioned: "But the increasing saturation of exoticism, as shown by the current tourist brochures called magazines, and complicated by a ridiculous and expensive and supposedly indispensable panoply of sophisticated lenses, convinced me long ago that exoticism really wore a gray polyester suit and lived half a mile away from me."

THE MAGNUM AGENCY

"Photography should not try to prove anything, but it can convince when it is not trying to convince anyone," says Marc Riboud. "It can't change the world, but it can show what the world is like, especially as it changes."

The cooperative enterprise known as Magnum was officially begun May 22, 1947, by Robert Capa, Cartier-Bresson, David Seymour and George Rodger after thinking about it, dreaming about it, wanting it during the long years of the war and later in the editorial offices of magazines like *Life* and *Look*. From the very beginning, the agency's founders, who were Hungarian, American, French, and English, intended it to be an international organization and it has always been open to new members from other nations. The objectives of the new cooperative were characterized by utopianism and realism, and were based on two main

principles: to ensure the moral and financial independence of all its members, who formed one large family, and to allow them legal rights to their own works. Thus Capa spoke of a "brotherhood" protected from editors and censorship, one which would portray war the way it really was and not heap praise unless it was deserved. At that time, the managing editors of papers and magazines were rather authoritarian and often had the final say over the photographs they would publish. They assumed ownership of the negatives, and the photographers lost all control over the future use of their pictures.

While Magnum wanted to increase its members' responsibilities, it also wanted to stimulate creativity, produce original stories, hunt for new markets, and start a system of classifying negatives and prints so as to market them more easily. In 1950 two new recruits, Werner Bischof, a Swiss, and Ernst Haas, an Austrian, joined the original team, quickly followed by Erich Lessing, Inge Morath, Marc Riboud, and many others. Meanwhile Capa and Seymour had been killed at the fronts in Indochina and the Suez Canal zone (both in 1954, within a day of each other). Stories like "Generation X"—on war babies—"People are People, the World Over," and "Monde des femmes" ("The World of Women") allowed each photographer to express himself freely within a joint consensus that would ensure Magnum's fame in newspapers, magazines, books, and exhibitions.

So that the meaning of the pictures would not be distorted, fully informative captions were attached to the back of each photograph; in some cases these captions amounted almost to an article. Of course it was inevitable that certain magazines would ignore the rules laid down by Magnum and that insensitive art directors would butcher the pictures by cropping them or completely falsifying their content.

Magnum-Europe, which has always been based in Paris, has about ten peripatetic photographers, while the agency's headquarters sends the work of its members—roughly twenty—all over the world. The disappearance of the larger magazines and the crisis that the so-called prestige press is undergoing—to the bene-

fit of the scandal sheets—has forced Magnum to become more and more commercially oriented. Cartier-Bresson dropped out of Magnum in 1966 but left his collection of stock pictures with the agency, which still distributes them today.

One of the more notable members of the agency is Marc Riboud, who joined Magnum in 1954 at Cartier-Bresson's invitation and shot stories all over the world. He is especially well known for his work depicting the birth of new African nations, on China before and after the Cultural Revolution, and on North Vietnam. Although his pictures are rigorously formal, they convey his love for the people he photographs. His deepest concern is to use his knowledge of current events and history to depict man in relation to the world around him and to strengthen his belief that one day all peoples will live in peace. His stories are the result of careful preparation and study, and always spring from his political convictions; they are in no way motivated by the desire to make a dramatic impression.

Bruno Barbey became a member of Magnum in 1968 and his work has been widely published in *Paris-Match, Life, Stern, Vogue,* and the series *Atlas de voyage.* He is one of the few photojournalists who use color intelligently: it does not distort or embellish his pictures, but reinforces the image in a subtle way.

Gilles Peress joined Magnum in 1974, and is particularly interested in social problems (miners, country life in France, immigrant workers); his pictures are personal and seem to question reality.

HENRI CARTIER-BRESSON
(1908–)

Cartier-Bresson's development reached full flower during the heyday of photojournalism. Inspired to consider the specific nature of photography, he established esthetic and moral principles that were to leave their mark on his contemporaries and exert a far-reaching influence on future generations of photographers.

Today we are struck by the quantity and quality of Cartier-Bresson's work, especially his picture essays: they do not contain any immediately obvious

message but teem with bits of information that force themselves on our attention and can eventually be perceived not as fragments of current events but as spaces to be seen for what they are—in other words, as photographs. It is easy to distinguish a Cartier-Bresson photograph from others taken of the same event. Such perfect order reigns amid the disorder that it seems to be the result of pure chance, but of chance that can be summoned at will. It is as though the photographer were part of his surroundings, had melted into them so completely as to modify their elements. For Cartier-Bresson, there is more to the act of photographing than its practical results and purely esthetic pleasures: for him it is a way of shaping the mind and bringing it into contact with the ultimate reality. Like archery in Zen, photography thus becomes a kind of spiritual development in which one's discipline and practice in the task make the camera into a natural extension of the eye. "The most important thing should be for the photographer to be fully aware of the real world as he sees it through his lens and breaks it down through his viewerfinder."

The "real world" Cartier-Bresson refers to is the source of all the material he needs for his work, and he enthusiastically takes part in its political and social activities not merely to justify himself, but as a way of observing the world and trying to understand it. In 1934, at the age of twenty-six, after studying painting with André Lhote, he joined an anthropological expedition to Mexico and then worked as Jean Renoir's assistant on a documentary film about the Republicans during the Spanish Civil War. In 1943 he worked with an underground movement to help prisoners and refugees, and joined a group of photographers covering the German occupation and the liberation of Paris. After helping to found Magnum, he spent three years in the Far East and was present in Indochina when it won its independence; in 1954 he photographed in the Soviet Union, then returned to China for three months on the occasion of the tenth anniversary of the People's Republic. He photographed Cuba in 1960, India and Japan in 1965, and Paris during the demonstrations of May 1968.

Although he has produced more than twenty books and held several large exhibitions of his photographs, it is in the prefaces to two of his books—*Images à la sauvette* (*The Decisive Moment*) (1952) and *Flag-rants délits* (*Caught in the Act*) (1968)—that he expresses precisely what he thinks of photography. "Photography appears to be a simple matter, but it demands powers of concentration combined with mental enthusiasm and discipline. It is by strict economy of means that simplicity of expression is achieved. A photographer must always work with the greatest respect for his subject and in terms of his own point of view . . . In my opinion photography has not changed since its origins, except in technical aspects, and these are not my major preoccupation. Photography is an instantaneous operation, both sensory and intellectual—an expression of the world in visual terms, and also a perpetual quest and exploration. It is at one and the same time the recognition of a fact in a fraction of a second and the rigorous arrangement of the forms visually perceived which give to that fact expression and significance." (*The World of Henri Cartier-Bresson*)

With this definition, concentrated into a few sentences, Cartier-Bresson laid the foundation of a whole intellectual and artistic school, which believes that photography is an independent and original art, deriving its uniqueness from its own technique. Although a camera, and especially the Leica, can only be considered the "driving belt" of the person holding it, it is nevertheless an object of sublimation and crystallization. With its normal lens and silent shutter, the Leica allows the photographer to take pictures without being noticed (a new type emerges: the invisible photographer). As a result, the full image—without cropping of the negative—must be composed in the viewerfinder at the moment the picture is taken (evidence of this is the thin black outline that frames the printed photograph). This presentation of photographs bordered by a black line, so fashionable nowadays, is a result of Cartier-Bresson's rigorous objectivity.

But what seems most important in Cartier-Bresson's work is the idea of the "decisive moment." When carried to its extreme, this idea transforms the human scene into a succession of "blessed" moments, captured on film at $\frac{1}{125}$ of a second by a few privileged people. This idea is currently being vigorously opposed by the advocates of the school of photography for which every moment in life is important and deserves to be photographed.

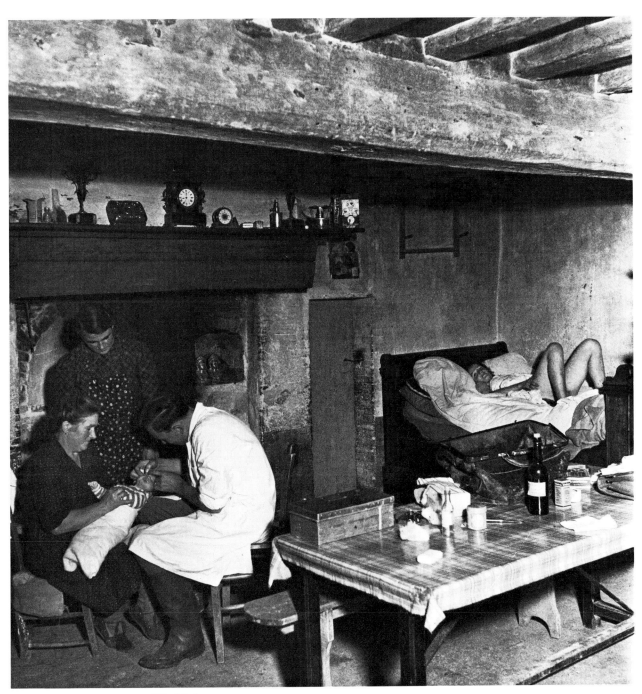

JEAN-PHILIPPE CHARBONNIER, *The Birth*, 1950

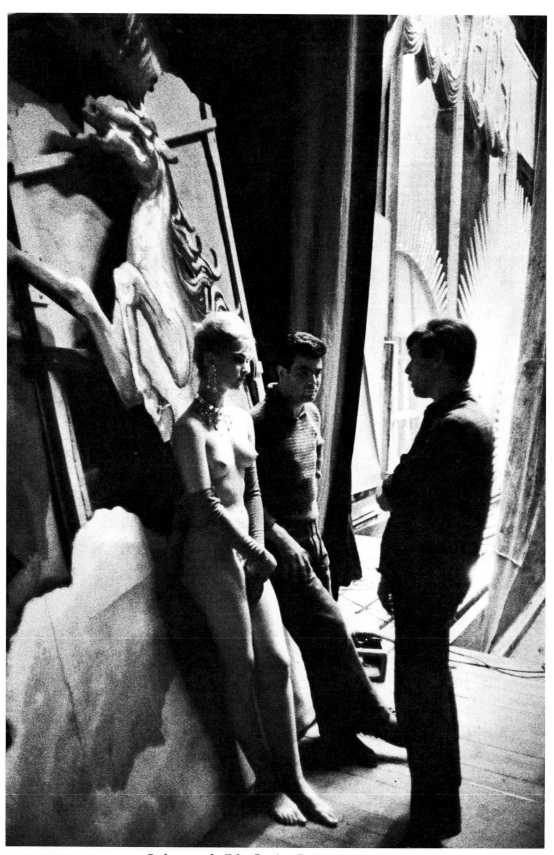

JEAN-PHILIPPE CHARBONNIER, *Backstage at the Folies-Bergères*, Paris, 1960

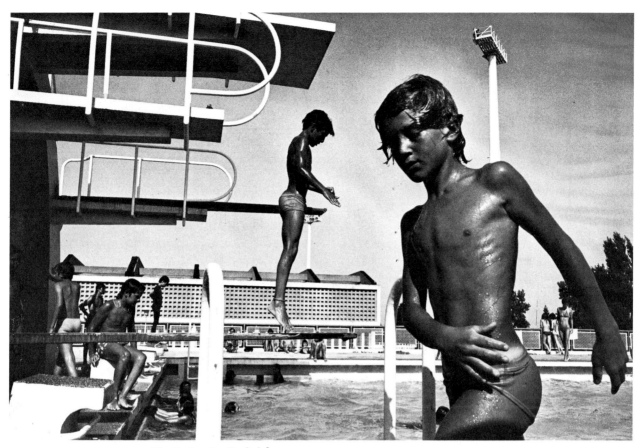

JEAN-PHILIPPE CHARBONNIER, *The Swimming Pool*, Arles, 1975

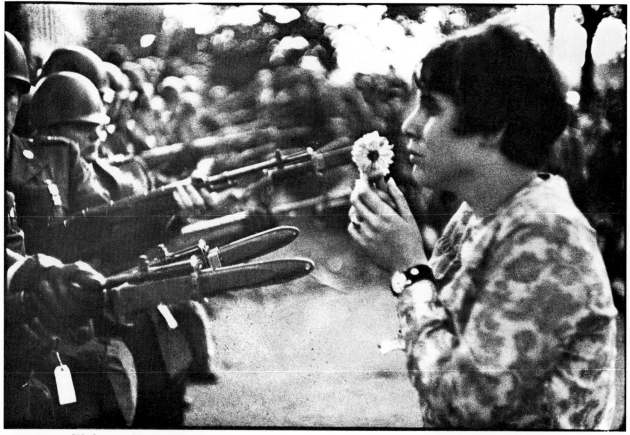

MABC RIBOUD, *Washington March*, Magnum, 1967

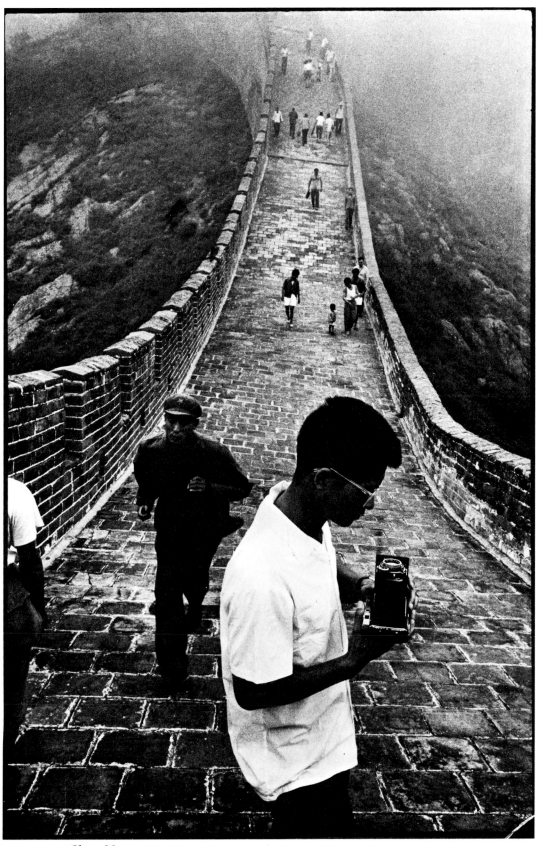

MARC RIBOUD, *China*, Magnum, 1971

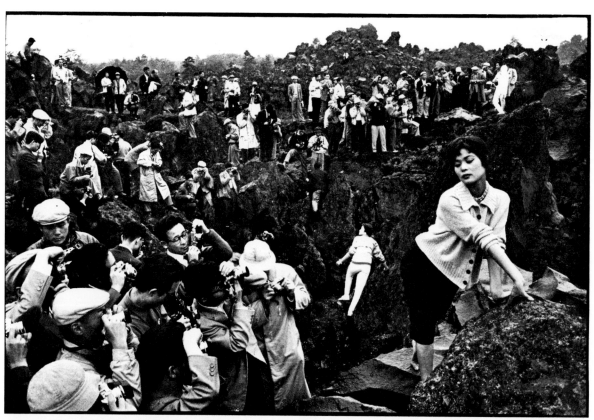

MARC RIBOUD, *Japan*, Magnum, 1958

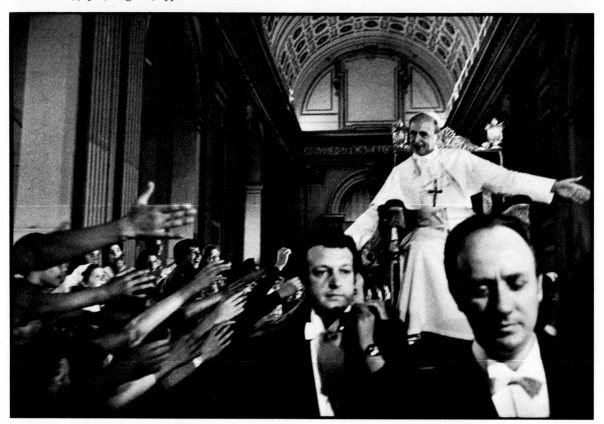

MARC RIBOUD, *The Vatican*, Magnum, 1972

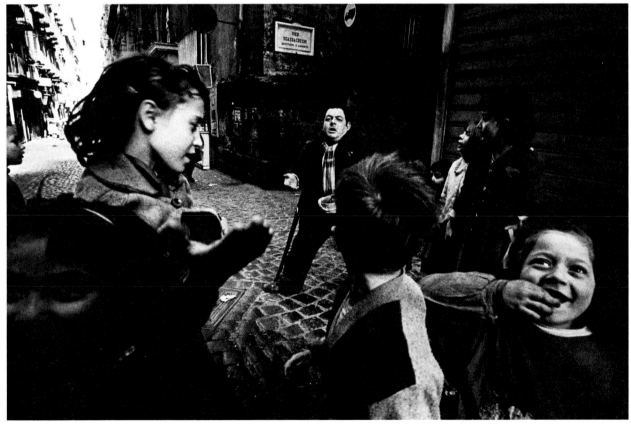

BRUNO BARBEY, *Italy*, Magnum, 1965

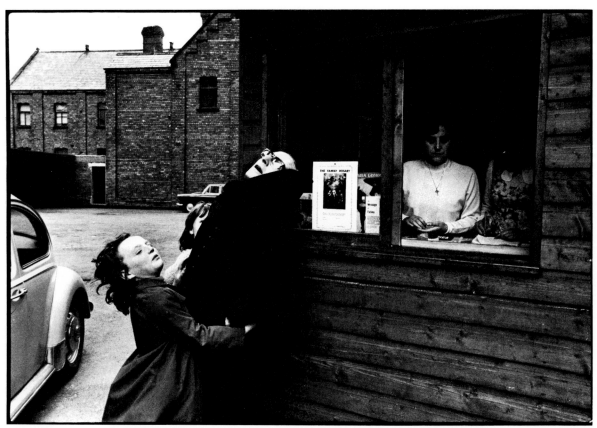

GILLES PERESS, *Belfast*, Magnum, 1972

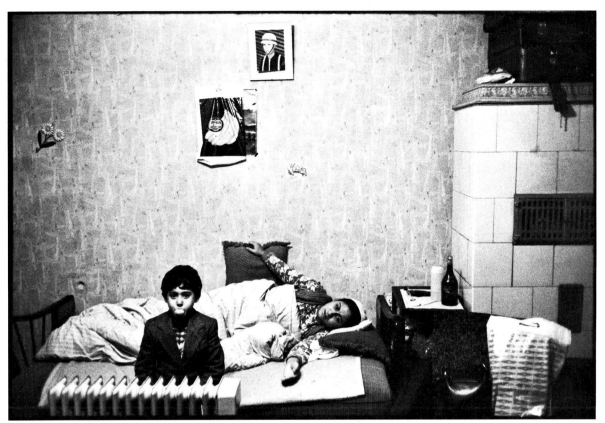

GILLES PERESS, *Immigrants in Germany*, Magnum, 1973

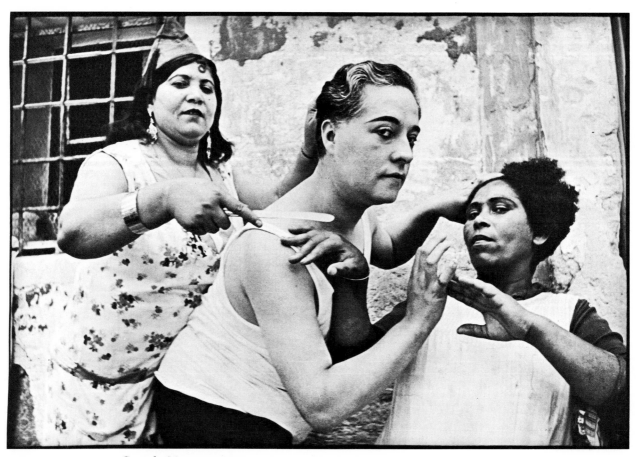

HENRI CARTIER-BRESSON, *Granada*, Magnum, 1932

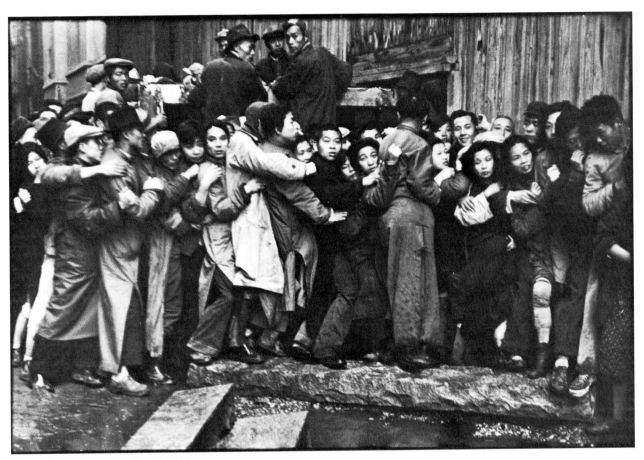

HENRI CARTIER-BRESSON, *Shanghai*, Magnum, 1947

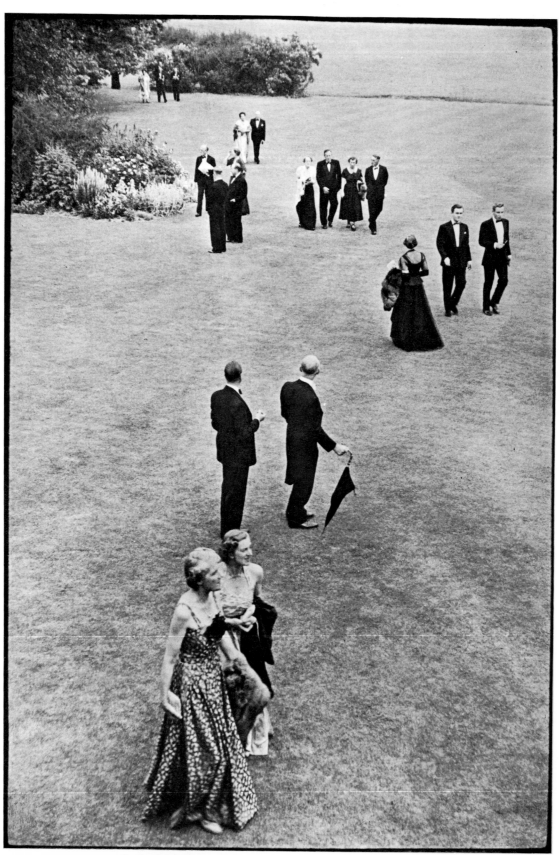

HENRI CARTIER-BRESSON, *England*, Magnum, 1955

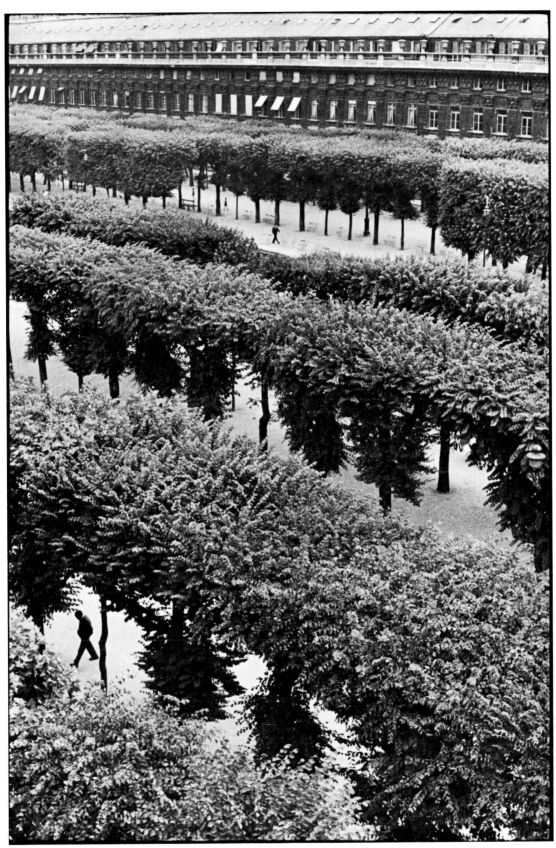

HENRI CARTIER-BRESSON, *Palais Royal*, Magnum, 1959

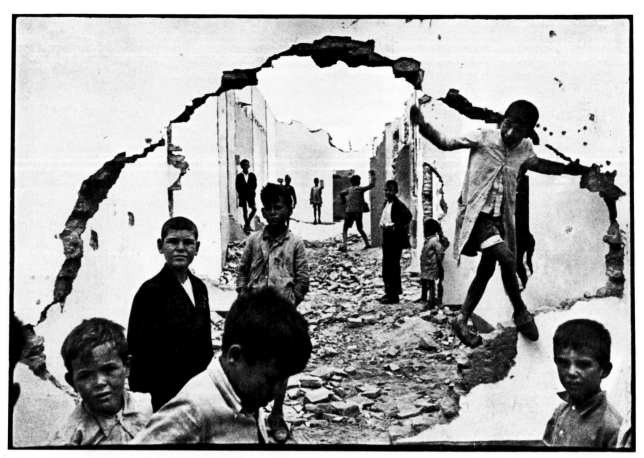

HENRI CARTIER-BRESSON, *Seville*, Magnum, 1932

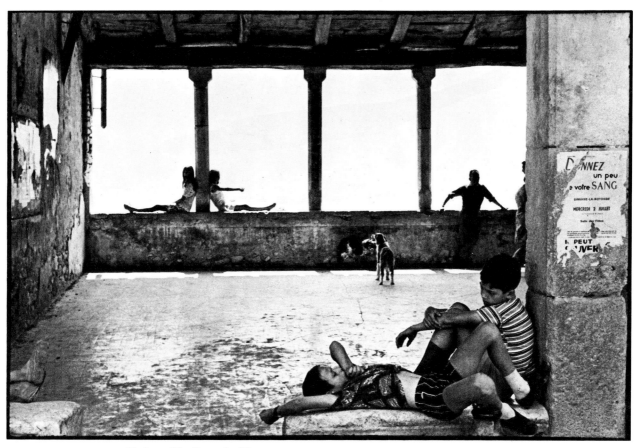

HENRI CARTIER-BRESSON, *Simiane, The Rotunda*, Magnum, 1970

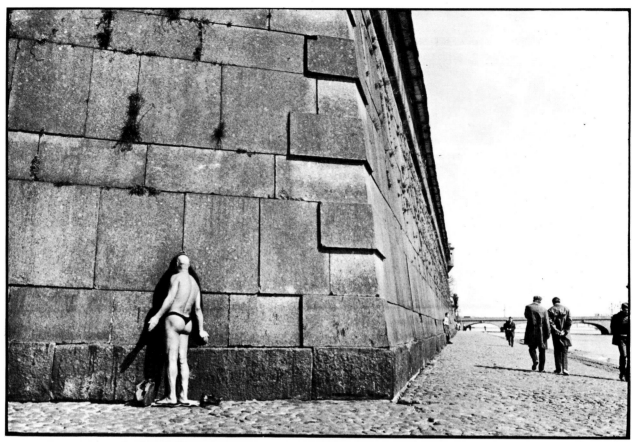

HENRI CARTIER-BRESSON, *Leningrad*, Magnum, 1973

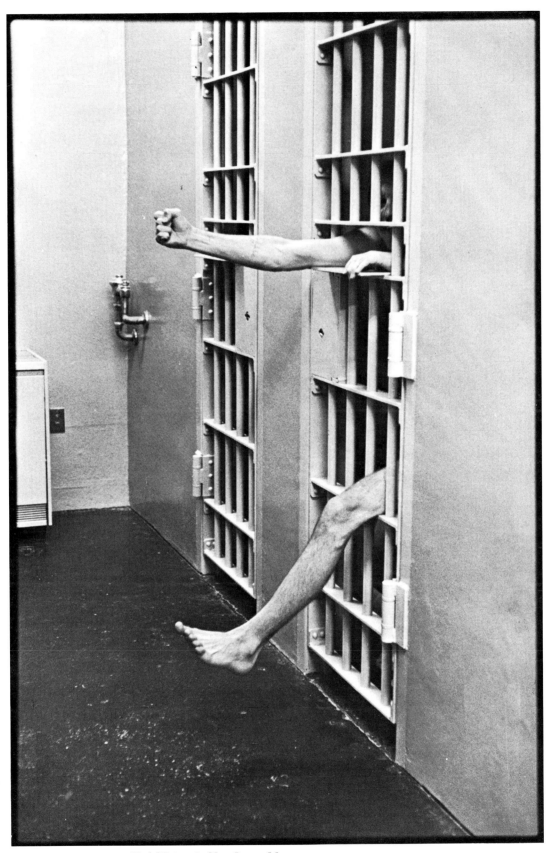

HENRI CARTIER-BRESSON, *Model Prison in New Jersey*, Magnum, 1974

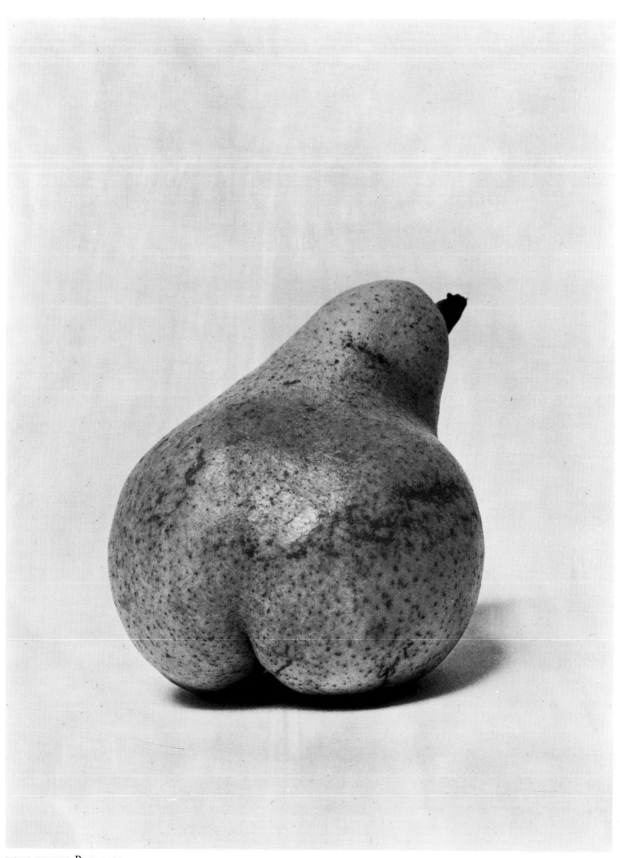

DENIS BRIHAT, *Pear*, 1972

Unlike photojournalists and reporters in general, who are primarily interested in people within their societies and whose main concern is to convey information and act as witnesses, photographers like Denis Brihat, Jean-Pierre Sudre, Jean Dieuzaïde, Lucien Clergue and Jean-Claude Gautrand—most of them scattered through the south of France—compose very personal pictures that draw upon nature for their subjects. These photographers take any material at all and turn it into a metaphor that reflects their inner life as accurately as possible. Although there are generally no people in their pictures, which are not figurative, the human being can nevertheless be perceived through matter or in symbolic figures. Often opposed to the photography produced in Paris, with its commercial overtones, these photographers have tried to bring the idea of craftsmanship back into favor and along with it a new life style.

In 1963 a number of them formed a group called "Libre Expression" (Free Expression), whose manifesto said: "We believe a creative photographer is one who acts on the subject in some way before or after taking the picture, thus going beyond simple representation." Their work is similar in feeling to that of the American Weston school, in that they attach great importance to photographic technique, even going so far as to invent, prepare, and manufacture certain products themselves. They want their pictures to become precious and unique objects, the results of a high level of craftsmanship. Since the sixties their photographs, which may truly be contemplated as seriously as paintings, are shown in private galleries and museums and are sold as works of art.

While occupied with their own work, these naturalists have tried to raise the status of photography, and have fought to have it taught in universities along with fine arts courses. Today there is some question whether that struggle was in vain, whether the work they did to raise the value of photography did not in fact serve commercial interests and consign photography to the world of the traditional arts, while modern trends are questioning this very notion of art as they try to bring creation and life together.

Denis Brihat, Jean-Pierre Sudre, Jean Dieuzaïde, and Lucien Clergue could be called a "Southern School," since all four of them live in the south of France. Firmly implanted in a region that still maintains its original roots and traditions, surrounded by a landscape still more or less intact (but beware of developers!), they have been able to capture the many symbols contained in the shapes of plants and rocks.

Denis Brihat, a sort of farmer photographer, combines his love of plants and fruits with many different chemical manipulations and processes, including sulphurization, oxidation, and corrosion, through which he obtains prints that are close in color and texture to rocks. In 1963 he produced "A Lemon," a portfolio of eighteen original photographs which he printed himself in an edition of fifty, and his work has continued in the same direction since then.

Jean-Pierre Sudre brought old photographic processes back into fashion and invented new ones, such as those that produce his *cristallographies* and *matériaugraphies* (chemical products laid between two pieces of glass and placed directly in the negative holder of the enlarger). In 1969 he had a show at the La

JEAN-PIERRE SUDRE, *Sun*, 1974

Demeure gallery in Paris in which he put together several 30 × 40 cm. prints, and called the work "Apocalypse." He was not so much trying to materialize a biological phenomenon by his use of three grams of crystalline matter, as to explain in his own way a synthesis of the universe and to make concrete his feeling of "cosmic instability." Since 1972 he has been director of a research center for creative photography in Lacoste.

Jean Dieuzaïde, born in 1921 in Grenade-sur-Garonne, took his first pictures during the liberation of Toulouse. As a professional photographer, he has specialized in regional archival work and research, while at the same time taking a leading role in the promotion of the arts by founding, in 1964, the "Libre Expression" (Free Expression) group. He is presently director of the Galerie Municipale du Château d'Eau in Toulouse, which has a permanent photographic exhibit. Although in 1971 he created stamps, rugs, and *centrichimigrammes*, his most impressive work is still *Mon aventure avec le brai (My Adventure with Pitch)* which he began in 1958 and finished in 1960. It was published in book form in 1974. Using pitch, a thick, black, sticky by-product of coal, Dieuzaïde established a true dialogue with matter in lines and forms that are fleshy and sensual and that became a means of profound self-expression.

Lucien Clergue was born in Arles in 1934. Since 1954 he has been depicting the mythic traces and emblems of the Camargue region in a lyrical manner. Using the female body as a symbol of eternity, he explores its form and volume in the minutest detail, combining it in his compositions with natural elements such as the beach, waves, sand, and the sea. His name has become known because of his association with Picasso, Manitas de Plata, and Jean Cocteau, as well as for the many fine books he has produced in collaboration with different poets—these include *Née de la vague (Born of the Wave)* in 1968 and *Genèse (Genesis)* in 1972. Since 1970 he has directed the Rencontres Internationales de la Photographie in Arles, a kind of Cannes Festival for photography that has established the reputation of American photographers and has created the "star system" in photography.

Jean-Claude Gautrand, born in Pas-de-Calais in 1932, is not geographically related to the other naturalists. He portrays the presence of man in architecture and buildings. Starting with his first book, *Murs de Mai (The Walls of May)* in 1968, and continuing through his *L'Assassinat de Baltard (The Murder of Baltard)* in 1972 and *Forteresses du dérisoire (Strongholds of the Ridiculous)* in 1977, his preoccupations have involved him in social tensions and political events. Using a wide-angle lens and a red filter, and printing very dark pictures, he creates grandiose and dramatic photographs whose lyricism sometimes overwhelms their political message. Since starting the Gamma group in 1963 and then "Libre Expression," he has been working as critic for several specialized magazines, including *Nouveau Photo-Cinéma, Jeune Photographie, Nueva Lente,* and others.

JEAN-PIERRE SUDRE, *The Jar of Eggs,* 1954

JEAN DIEUZAÏDE, *Cytology*, 1972

JEAN DIEUZAÏDE, *My Adventure with Pitch*, 1958

LUCIEN CLERGUE, *Born of the Wave*, 1968

JEAN-CLAUDE GAUTRAND, *Strongholds of the Ridiculous,* 1977

JEAN-LOUP SIEFF, *Portrait of a Woman in Black*, England, 1964

SURVIVORS OF FASHION
AND ADVERTISING

To the rest of the world, Paris has always been the capital of gaiety, good taste, pretty women, luxury and fashion. Although it still has this reputation, we know that Paris no longer belongs to the Parisians; reckless urbanization, stimulated by big developers, has wiped out the spirituality and soul of the city. Yet the tradition continues, promoted by a luxury industry dealing in fashion, ready-to-wear clothing, perfume, and jewelry, that spends money in ingenious ways to maintain its highly sophisticated image. Since 1920, photography has had an active role in creating —has even succeeded in materializing in reality—the image of the man or woman who wants to be fashionable, who wants to belong to an élite. Everything is appearance, everything is visual.

Magazines and advertising agencies were created in the United States and Europe after the two world wars to give a new impetus to the tottering economy by appealing to people's private dreams. The years from 1920 to 1950 represented a boom period for high fashion; during the sixties a pseudo-liberation of the sexes took place in which the female body became a vehicle for promoting and selling beauty products and miracle creams of all sorts. Photographers were frequently reduced to simply following directions as they worked for clients who were chiefly concerned with selling their products, and could only rarely express their personalities or give free rein to their imagination. Nevertheless, exceptions did exist, the result of long struggles between the photographers and the demanding commercialism of their clients.

Vogue Paris and *Jardins des Modes*, which were started in 1921 by the American Condé-Nast, have always used the world's best photographers to create an image of quality and to make these magazines the springboards of all that is new and daring. These pho-

tographers, with excellent technical and professional backgrounds, use a great deal of new equipment and have at their disposal vast picture-taking studios with electronic flash and strobe equipment, allowing them to invent a totally fabricated universe in a new light. The model repeats the same gesture *ad infinitum*, perpetuating the myth of woman as object.

The work of Guy Bourdin and Helmut Newton is prominently featured, particularly in the pages of *Vogue*, while the pictures of Jean-Loup Sieff, Jean-François Bauret, and Jean-Paul Marzagora have appeared in both advertisements and exhibitions.

After being hired by the magazine *Elle* in 1955, Jean-Loup Sieff worked for all the most important magazines—*Jardins des Modes, Glamour, Harper's Bazaar, Look, Esquire,* and *Twen*—before settling permanently in Paris in 1965, where he opened a studio and began to work regularly for *Vogue* and *Elle*. It was at this time that he began to produce his most forceful pictures, highly contrasted black-and-white photographs of mournful landscapes and nudes in which his use of the wide-angle lens created a special kind of poetry. He is indirectly responsible for a photographic style in which wide-angle lenses are used to capture the subject and its surroundings in a single picture. For many young French photographers unfamiliar with the work of the Englishman Bill Brandt, Jean-Loup Sieff's photographs were a major discovery that gave black-and-white photography a healthy second wind. Jean-Loup Sieff's world is composed of sharply contrasting areas in which white masses furrowed with ferricyanide throw darker tonalities into relief and create the same mysterious sensuality which exists in his portraits and his nudes, which are often photographed from the back or three-quarters view.

JEAN-LOUP SIEFF, *Nude on a Bed*, Paris, 1970

JEAN-LOUP SIEFF, 1978

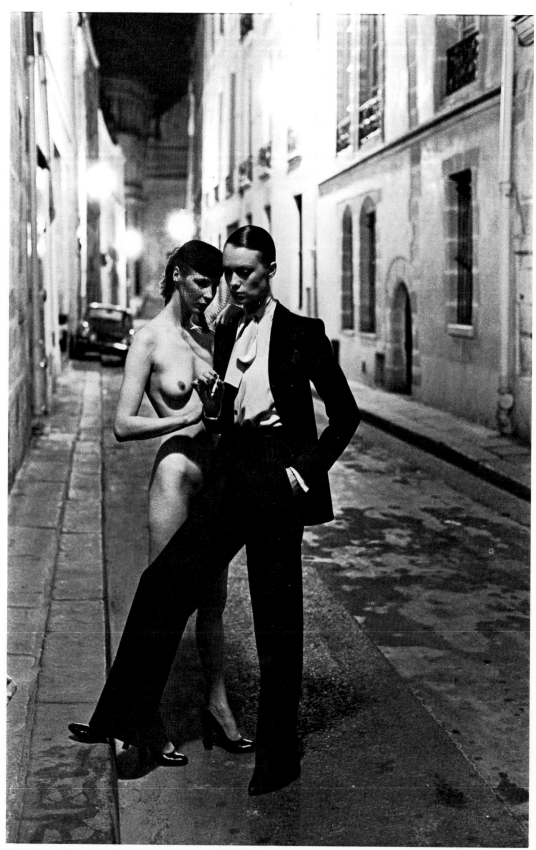

HELMUT NEWTON ©, *Secret Women*

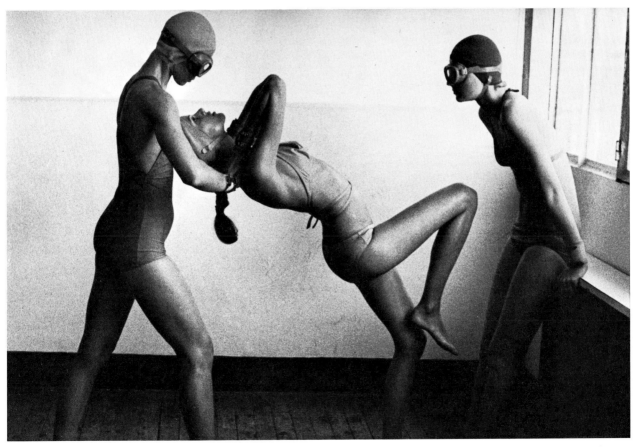

HELMUT NEWTON ©, *French Vogue*

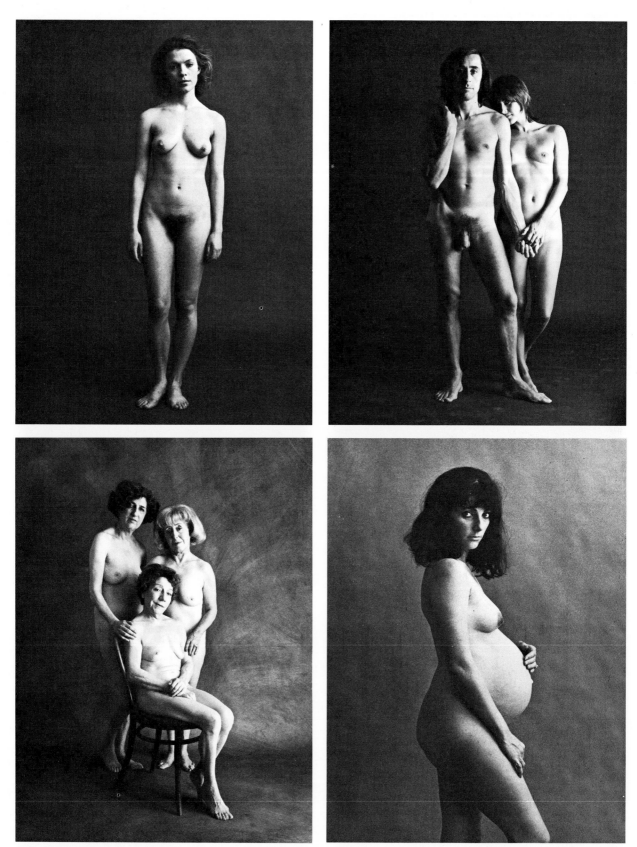

JEAN-FRANÇOIS BAURET, *Portraits*

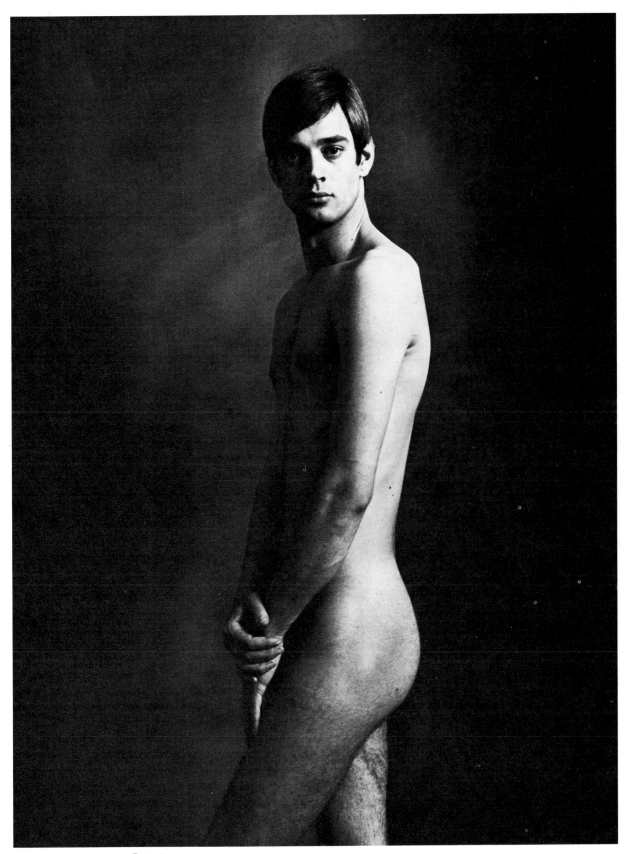

JEAN-FRANÇOIS BAURET, *Portrait*

In their own ways both Guy Bourdin and Helmut Newton brought new life to fashion magazines sinking under the weight of unrelieved boredom. Leafing through a copy of *Vogue,* one immediately recognizes their work, because it has openly broken away from the conformity around it.

Since the early sixties, Guy Bourdin has become well-known for his pictures, in which imagination and fantasy break through the overly rigid conventions of commercialism. An indefatigable innovator and seeker as well as a remarkable graphic artist, he does not hesitate to use the gaudiest colors or create the most extravagant makeup. In the advertising campaigns he has photographed for Charles Jourdan, he featured shoes in romantic or surrealistic situations. These pictures did not incite the public to go out immediately and buy the shoes, but rather confronted the viewers with imaginary spaces that were able to make an impression on their subconscious minds.

The photographs of Helmut Newton—who carries to an extreme the idea of the middle-class woman as sex object—depict the last flings and fantasies of a certain class on the brink of decadence.

In June 1967 Paris was scandalized by a billboard posted all over the city. It was signed Jean-François Bauret and showed a nude man in profile praising a certain brand of men's briefs. A few years later, in 1971, Bauret exhibited a series of black-and-white photographs in the Arc section of the Museum of Modern Art in Paris. These depicted individuals "as they are," presented stark naked and with no special lighting effects, against a neutral background. The exhibition was disturbing because the nudity depicted had nothing to do with eroticism or exhibitionism and the people photographed did not seem to correspond in the least to current esthetic models. Bauret shocked the public again in 1975 with a new series

and a book entitled *Portraits of Known and Unknown Nude Men;* the show was never actually exhibited (the Nikon gallery in Paris backed out of its agreement under pressure from many different quarters). For more than twenty years, Jean-François Bauret has been spending most of his time in advertising and in carrying out his own research projects, which quite often share a common theme—the liberation of the individual. His photographs, showing ordinary men and women of all ages and all social strata completely stripped, are in some way trying to fight sexual discrimination and show each person as he or she really is.

Jean-Paul Merzagora worked as a photographer for only three years (he committed suicide on December 24, 1972, at the age of thirty-three). But the pictures he took during that brief time give us some indication of what he was like. His overflowing fantasy, intuition, and imagination had an immediately subversive effect on post-1968 photography. Merzagora was a highly paid model when he suddenly decided to step to the other side of the camera and put his spontaneity and ingenuity to work on photographic technique. Both in his color pictures (which were carbon-printed by Fresson) and in his black-and-whites, Merzagora depicted a fantastic and Baroque world in which his figures seemed filled with the same kind of calm serenity that characterized the work he did with food for *Votre Beauté* and *Elle.* Placing a screen over his lens and photographing natural elements that seemed to melt over female bodies, he obtained a pastel coloring somewhat resembling that of certain Florentine frescoes. One of his works was a long comic sequence, large sections of which were published in the magazine *Zoom,* a sort of picture story recounting the extravagant adventures of an inexperienced man caught in the most hilarious erotic situations.

JEAN-PAUL MERZAGORA

GILLES CARON, *May '68*, Gamma

In France, as well as in other countries, 1968 was the year youth rebelled against bureaucracy and the "establishment"; it was also a year of utopian dreams, of slogans and signs calling for freedom. An entire generation tried in every way possible to express itself, to develop new relationships with other people, to re-examine its ideas about life, happiness and politics. In France, the events of May marked the beginning of a new kind of communication that rejected all forms of power and outmoded ideology and sought to allow minorities to speak out in an original language. Graffiti appeared on walls, giving fresh significance to the force of gesture; slogans shouted during demonstrations seemed to unearth the meaning of poetic subversion; festivals returned to the streets and involved everyone in spontaneous and creative exchanges. After days of general strikes and revolutionary ferment, the May explosion was brought under control by the politicians and trade union leaders, and left widespread disappointment similar to that felt the day after a party, when life returns to its usual humdrum grayness. Yet the ideas, the hopes, the utopian dreams of May are not dead; they are still compelling to many of those who took part in the demonstrations. Amid a generation indiscriminately preoccupied by Vietnam, Maoism, demonstrations, California, "trips," communes, sexual liberation, pop concerts, "the road," and Asia, a renewal is sensed that will, in the normal course of events, have an effect on the cultural outlook. The artists to whom the events of May '68 had been a revelation are once more trying to define their identities and their role in society. They are trying to bring creativity and life closer together, to use their imagination not as a springboard for escaping reality but as a special way of directly transforming it.

Photography, solidly rooted in the confusion of the tangible world, gives them an opportunity to interpret reality in a precise, mechanical way, and to embrace its uncertainties.

Since the early seventies, hyper-realist painters have developed a technique that allows them to reproduce the most banal everyday subjects in an exact and faithful way, as though they were looking at the world through the camera's viewerfinder. Their goal is the same as the photographer's—to redefine reality, the mechanism of which has created a new iconography. The point is not simply to coldly analyze the outside world to represent human events objectively, but rather to project oneself into them so as to reveal them as open and questionable spaces. This subjective realism was to change the approach of photography completely and open the way to an independent language which would break with traditional interpretations of pictorial esthetics. There is a tendency to reject the way pictures are used, for example, in the large newspapers, certain photography clubs, and specialized magazines which push technique above all else.

Around 1972, a new generation of French photographers, most of whom had been eighteen at the time of the events of May 1968, began to emerge. They shared the same set of values, the same sense of negation and refusal. In an unorganized way they opposed the deceitful and élitist use of photographs as seen in the different media. They hoped to see the beginning of a different kind of discussion about the language of photography, one that would avoid idealism and go on to confront political and social issues. They wanted to produce a great quantity of pictures and start new publications that would reach as many people as possible.

It was during this period that many French photographers began to discover American photography, which was being exported to France with considerable American backing. They also wished to assimilate the new subjectivity that had developed in California and New York. The visions of Walker Evans, Robert Frank, Ralph Gibson, Lee Friedlander, and Leslie Krims had completely broken away from Cartier-Bresson's "decisive moment" to become statements about the sickness of American culture, in which isolated individuals seem lost in the world of technology.

After some inevitable excesses, this "new" or "creative" photography—a term used to differentiate it from commercial photography—gradually invaded all the traditional genres, which were not so much abandoned as reinterpreted. The leading exponents in France include Plossu, Bruno Requillart, Kuligowski, and Descamps. First in Paris and then all over the country, galleries devoted exclusively to photography have been opened. They have stimulated the circulation of creative photography and have reached a new public eager to look at pictures. In 1975, Claude Nori started Contrejour as a kind of center for contemporary photography, with its own magazine, its own line of inexpensive books, and which sponsored exhibitions. Photography festivals like those at Arles, Narbonne, and Royan allowed the most diverse kinds of confrontations to occur and gave people a chance to see the photography of other countries. Museums—including those in the Musée Municipal of Châlon-sur-Saône, the Château d'Eau in Toulouse, and in Montpellier, Brest, and Marseille—began to react to these developments by creating departments of photography. Certain art dealers began to specialize in the sale of original photographs and attempted to create a new market for photography, although this is not working out very well in France (an auction held in Paris in 1977 was a fiasco). Books of photographs, in many cases published by the authors themselves, allowed photographers the opportunity to communicate their vision of the world to others without spending very much money. Large magazines now devote whole pages to photography, and even publish special issues entirely given over to photography. After years of indifference, government organizations are now frantically eager for pictures, and in 1976 the National Foundation of Photography was established. Photography appeals to a younger and younger public, which delights in everything from comic strips and science fiction to photo-novels and record jackets.

After many exciting years of imitation and experimentation, French photography at last seems free of American influences. Certain important movements developed over the last few years can be distinguished in the profusion of new trends in contemporary photography.

THE NEW REPORTAGE

"We believe that we are politically mature and socially defined people. This, along with our feelings and our sensitivity, gives us the right to express the way we see things," wrote Guy Le Querrec in his book *Quelque part (Somewhere)*.

At present, most of the international news agencies are based in Paris. Gamma, Sygma, Sipa, Magnum, and Rush all distribute photographs that continue to be printed on the front pages of major foreign magazines. Newspaper photography, which has been repeating the same kind of message for more than ten years, is now part of a real system, an ideology of news with its own codes and production requirements. Presented as objective reports, photographs of war, violence, and catastrophe all assume an air of fatalism as they show us the troubles of the world, always taking the side of the victimized and the oppressed. The frequent use of the wide-angle lens has created a stereotype of the dramatic picture that borders on the hyper-real and gives the effect of having been "taken on the spot." The victims, in the foreground, seem to have come to exorcise the reader, to testify to the sufferings of the human condition while leaving historical reality behind them.

Yet certain photographers maintain the tradition of the "concerned photographer," and are producing high quality pictures that reflect the events of the last few years in a very personal light. They belong to the Gamma agency, which was started in 1968. Gilles Caron, for instance, who disappeared in Cambodia in 1970, became known for his pictures of Vietnam and the events of May 1968. Michel Laurent, who was awarded the Pulitzer Prize in 1972 at the age of twenty-six, was killed in Vietnam in April 1975. Raymond Depardon and Marie-Laure de Decker brought back astonishing pictures of the Toubou rebels in Chad, and Abbas makes us witness to racism in South Africa.

MICHEL LAURENT, *Addis Ababa*, Gamma, 1974

RAYMOND DEPARDON, Gamma

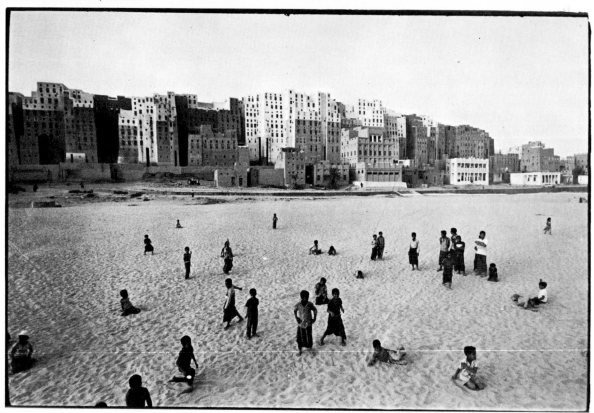

MARIE-LAURE DE DECKER, *South Yemen*, Gamma, 1974

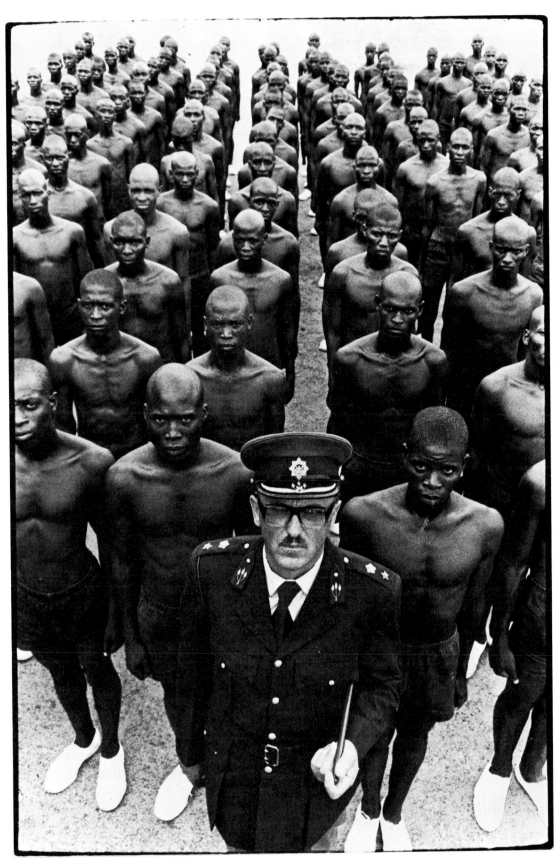

ABBAS, *South Africa*, Gamma, 1978

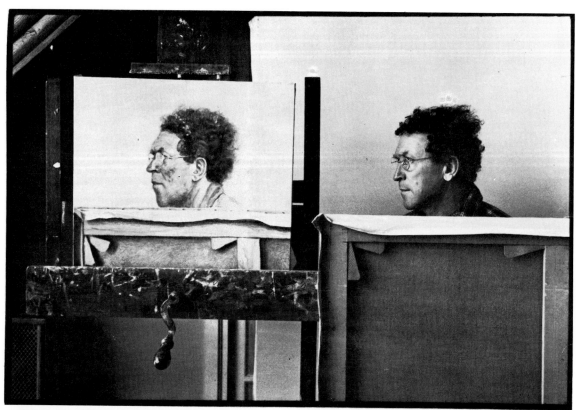

MARTINE FRANCK, Viva, 1976

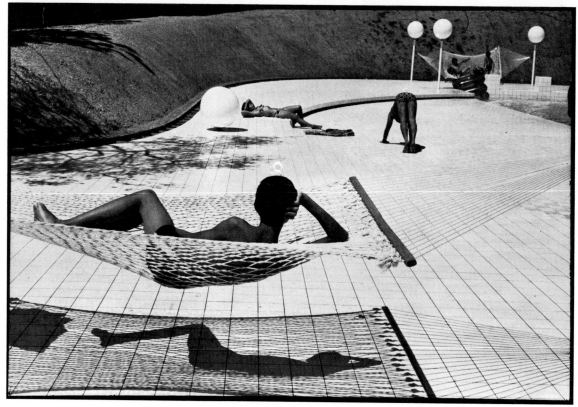

MARTINE FRANCK, *Provence*, Viva, 1976

Partly as a reaction to newspaper photographs and the way they are manipulated and used by the traditional media, seven photographers founded the Viva agency in 1972 and produced a collective work on the "family in France." Martine Franck, Guy Le Querrec, Richard Kalvar, François Hers, Hervé Gloaguen, Alain Dagbert and Claude Raimond-Dityvon (later joined by Michel Delluc) belong to the "post-May '68" generation whose social and moral preoccupations are shared by groups in other countries—the Swedish group Saftra and the collectives in Québec, for example. From the beginning there was a desire to form a group, to engage in a collective activity that could stimulate individual creativity, to keep in touch with the work of young photographers and draw fresh inspiration from it, and to recruit new members with similar professional preoccupations. The Viva agency intended to withdraw somewhat, to adopt a "calmer" attitude toward events and examine in depth whatever subjects it chose to treat. Viva has put its imprint on the market: it is a kind of photography that is concerned with the leisure-time activities of the working class and the subtle way the contemporary environment oppresses people. Although its main customer is naturally the leftist press, the agency quickly found modern methods of distribution that allow the work to reach a typical audience for photography (arts centers, exhibitions, books, etc.). While still members of an agency producing journalistic pictures, the photographers in Viva retain the right to differ with the agency and to pursue their own development, unaffected by the constraints of commercialism.

Claude Raimond-Dityvon, for example, who was a manual worker before he became a photographer, tries to depict the social world in which he has lived. His disciplined and poetic pictures express the loneliness of the ghettos, relationships among people, the crushing burden immigrants bear, and the coldness emanating from urban spaces. In an attempt to give his work a frankly political direction, he creates montages in the form of "storyboards" and makes films for television.

Guy Le Querrec, on the other hand, likes to think of himself as a troubadour-reporter whose camera is a kind of guitar. He is interested in human relationships and the bonds uniting the photographer, his subject, and the person looking at the photograph. He tries to share his experience as a professional, which he finds full of contradictions, and publicly expresses his opinions about the myths, the pictures, and the art that spring from the dominant ideology. His pictures, which seem to defy chance and put everything back in its place, belong to the tradition of Cartier-Bresson and Doisneau (and also seem to have been influenced by the wanderings of Robert Frank). He is now one of the leaders of this new, specifically French reportage, ready to give new vitality to the Magnum agency, which he joined in 1978.

Other photographers spend their time studying everyday scenes in their immediate environment, where they feel completely at home. Most of them are not professionals, and when they create reportages it is for their personal fulfillment or for social reasons.

Although Jean Gaumy is a member of Magnum, he devotes long months to pursuing specific themes (hospitals, prisons, etc.) somewhat in the American manner, without any clear commercial prospects.

Michel Thersiquel earns his living making portraits and wedding pictures in Brittany and is interested in his region's traditions.

Roland Laboye photographs slices of life that he juxtaposes into realistic sequences—adventures on the street corners of his native town of Castres.

Pierre Legall tirelessly photographs the daily activities of the people of Finistère, and then attempts to involve these people in his work by mounting photographic exhibitions on the very spots where he took his pictures (Dieppe, Le Havre, Finistère) and by publishing and printing his own books.

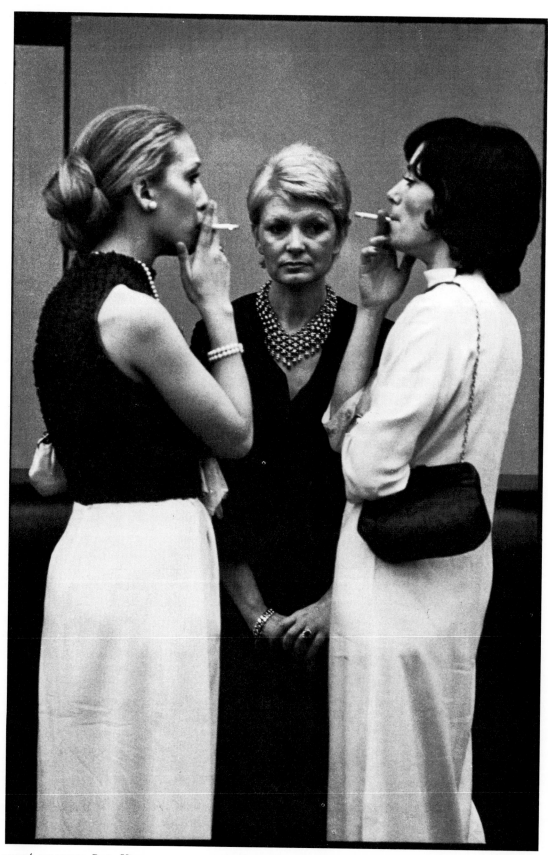

HERVÉ GLOAGUEN, *Paris*, Viva, 1972

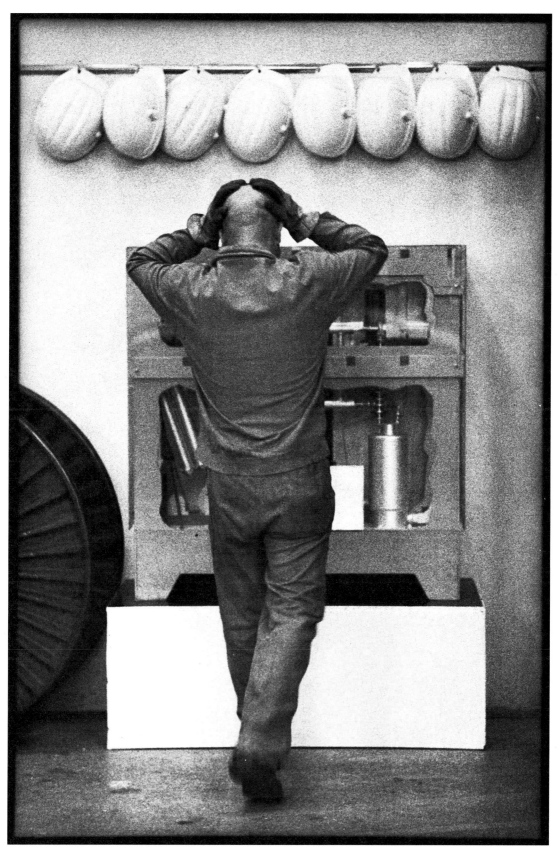

HERVÉ GLOAGUEN, Viva, 1972

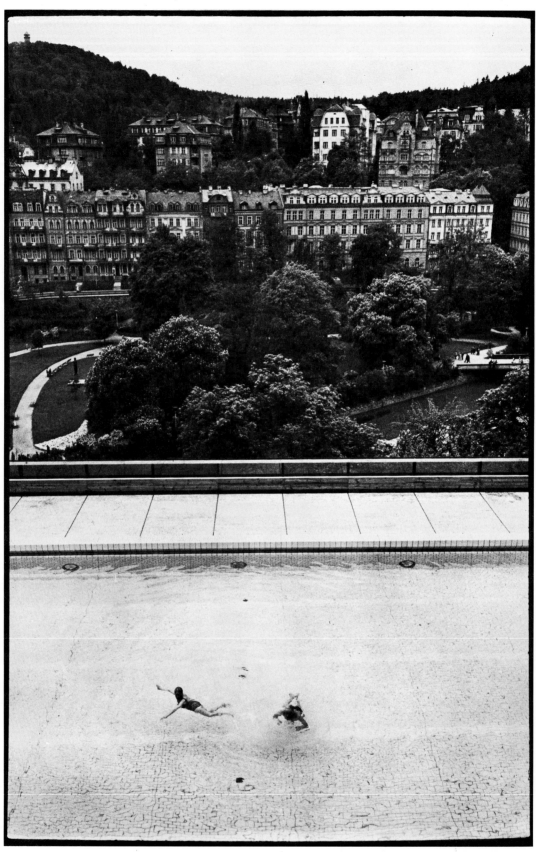

MICHEL DELLUC, *Czechoslovakia*, Viva, 1977

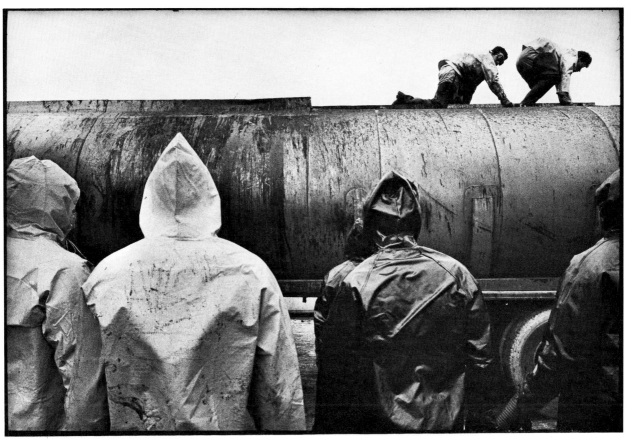

CLAUDE RAIMOND-DITYVON, *Oil Slick*, Brittany, Viva, 1978

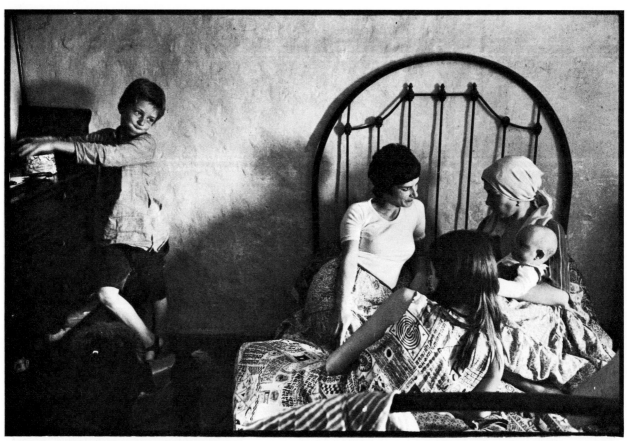

CLAUDE RAIMOND-DITYVON, *Saint Emilion*, Viva, 1973

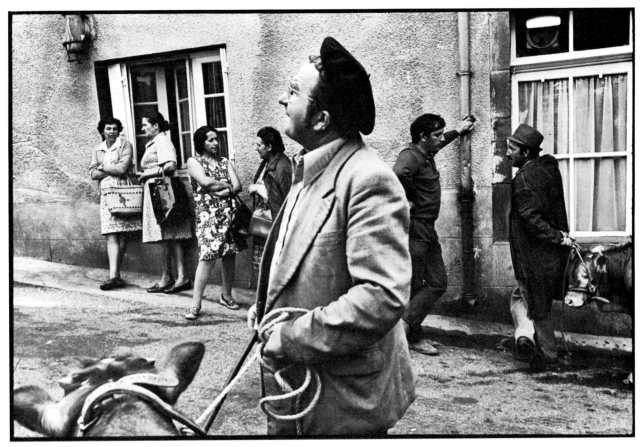

CLAUDE RAIMOND-DITYVON, *Meyssac*, Viva, 1977

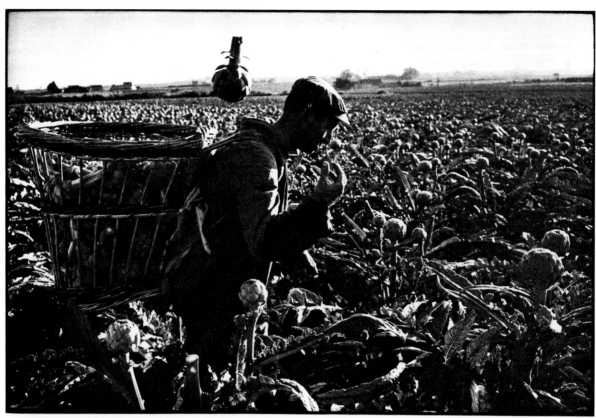

GUY LE QUERREC, *Brittany*, Magnum

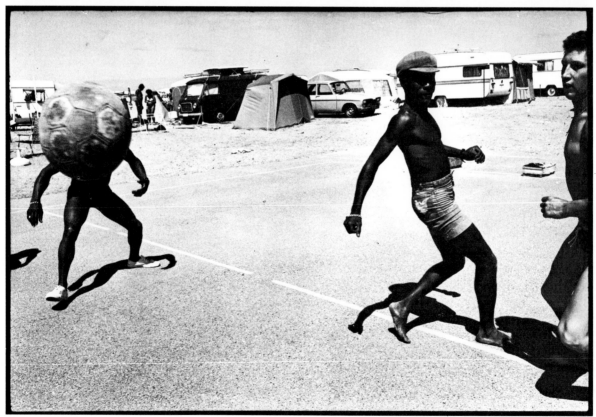

GUY LE QUERREC, *Argelès-sur-Mer*, Magnum

GUY LE QUERREC, *Villejuif*, Magnum

GUY LE QUERREC, *Brittany*, Magnum

GUY LE QUERREC, *Brittany*, Magnum

JEAN GAUMY, *Lisbon: Demonstration of the Portuguese People's Republican Movement,* 1975

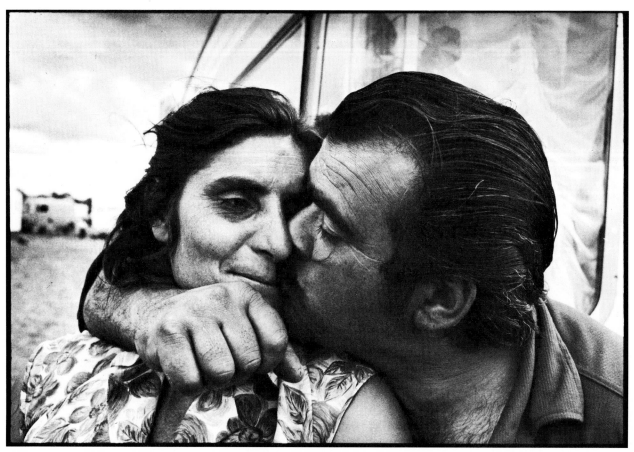

JEAN GAUMY, Magnum

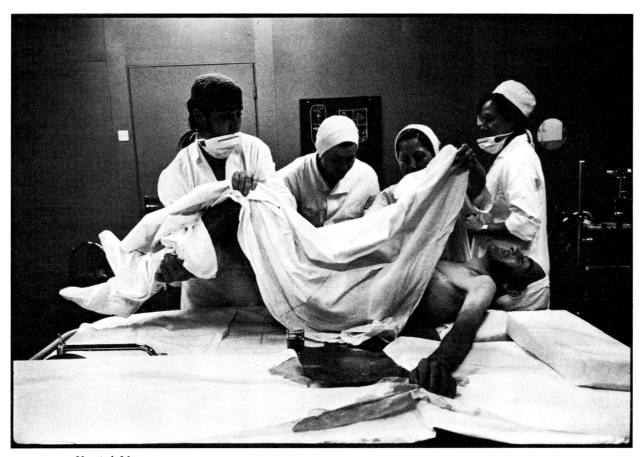

JEAN GAUMY, *Hospital*, Magnum, 1975

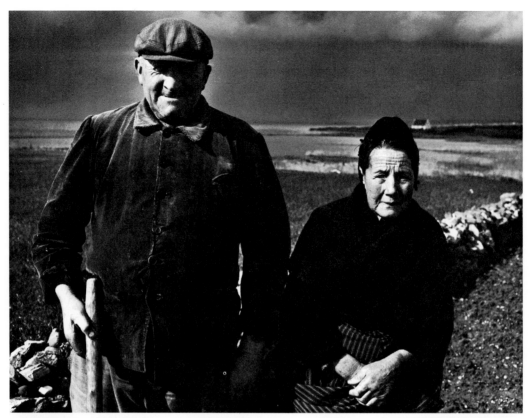

MICHEL THERSIQUEL, Brittany

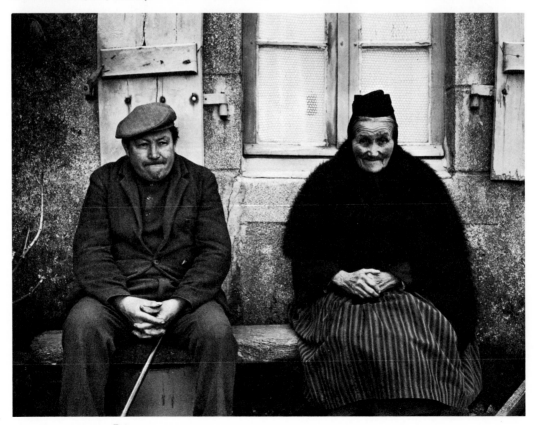

MICHEL THERSIQUEL, Brittany

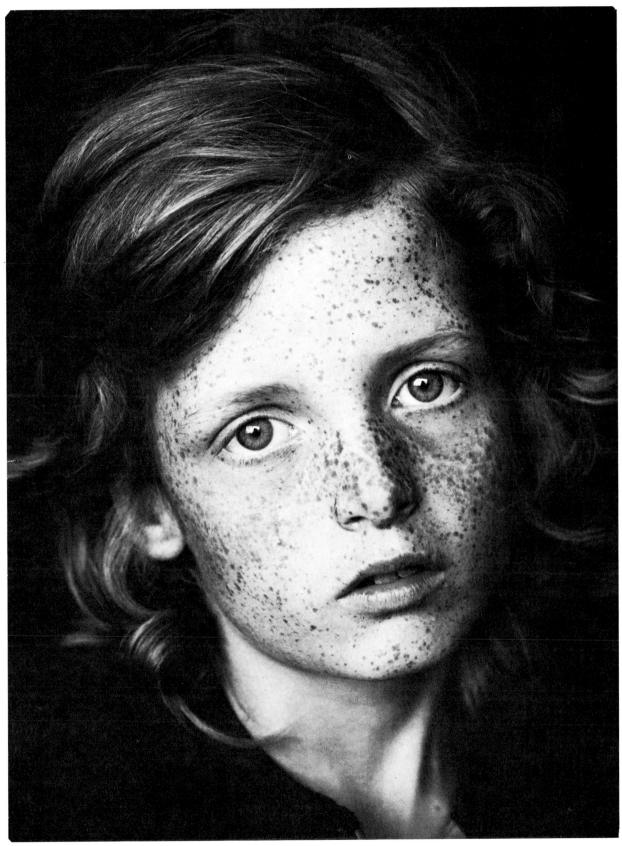

MICHEL THERSIQUEL

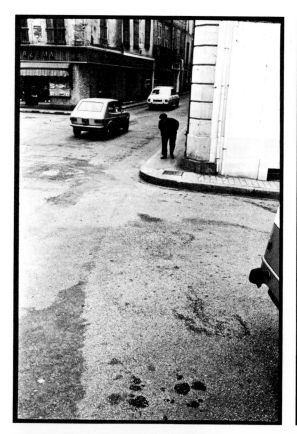
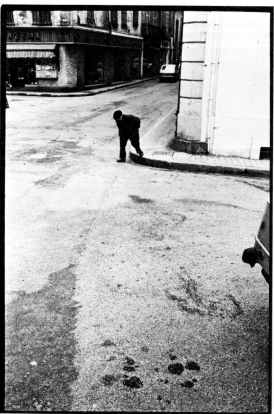
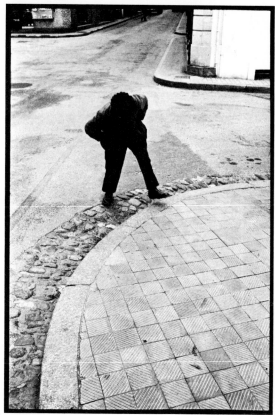
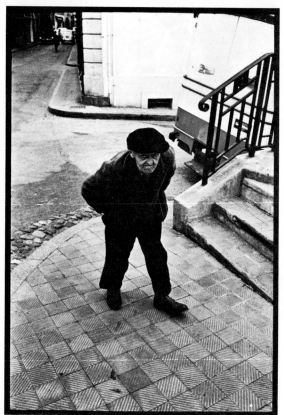

ROLAND LABOYE, *Sequence*

SUBJECTIVE REALISM

In much the same spirit as Eugène Atget, Walker Evans broke new ground in the 1930s by focusing on the most ordinary subjects, on things everyone could recognize, things in no way spectacular. He made colorless places and empty rooms resonate with the presence of the people who once lived in them. The creator projects himself on his subjects and invests them with his own inner world.

In the early fifties, another practitioner of American avant-garde photography, Swiss-born Robert Frank, astounded the public with his book *The Americans*. In a style of unparalleled density he portrayed the oppression, loneliness, and frustration felt by millions of young Americans. His pictures were not fragments of reality, nor were they the carefully structured kind of photographs that could elicit a complacent kind of admiration: they were statements of a certain state of life, a collection of damning pieces of evidence that constituted an autobiographical and subjective essay. It was not America as such that mattered, with its clichés and its puritanical conventions, but an America seen by a man who during his often crazed wanderings, seemed to take on the burden of the whole country. This subjective realism does not pretend to show the world as it actually is, but as it is experienced individually, colored by beliefs, fantasies, and the reigning ideology of the time.

In France, this trend is followed—to varying degrees—by a growing number of young photographers who share an enthusiasm for pictures in a complementary series and are doing new work along those lines. There is a certain bluntness and an extreme technical simplicity in most of these photographs. The story they tell often emerges as an interior reportage that seems less violent, less brutal than that of the American school—as illustrated by Charles Harbutt, Burk Uzzle, Lee Friedlander or Charles Gatewood—and that questions reality in a more nuanced and subtle way.

Bernard Plossu, one of the leaders of this movement, has played a large part in making the California-style contemplative photograph known in France through his many trips to the United States since 1966. Fascinated by the hippie movement, the craze for traveling, Eastern thought, and the naive humor of early comic strips, his pictures contain a whole philosophy of life, such as might have been expressed and experienced by Jack Kerouac or Bob Dylan. In his book *Surbanalisme (Superbanality)*, which appeared in 1972, he used extremely funny pictures to try to integrate the notion of time with the study of human behavior in everyday situations, and also to make fun of so-called "adult" activities when they somehow threaten the rhythm of the seasons and the harmony of immutable values. Later he made many trips to Africa, Mexico, and Egypt, where horizons are vast and serene and the people exude a certain inner richness. His photographs express the quality of silence, and are a poetic form of documentation. In 1975, he took part in an exhibition organized by Jean-Claude Lemagny at the Bibliothèque Nationale of Paris along with Bernard Descamps, Eddie Kuligowski, and Bruno Requillart, who were all working in the same direction, combining to establish this "new photography" solidly in France. For these photographers, reality is broken up into a number of forms and spaces within which truly organic relationships exist.

Bernard Descamps is interested in household furniture and urban structures.

Eddie Kuligowski prefers the vast spaces of the subway, and beaches where man seems to have lost his way.

Bruno Requillart photographs the sensuality emanating from the stones and plants in public gardens.

BERNARD PLOSSU

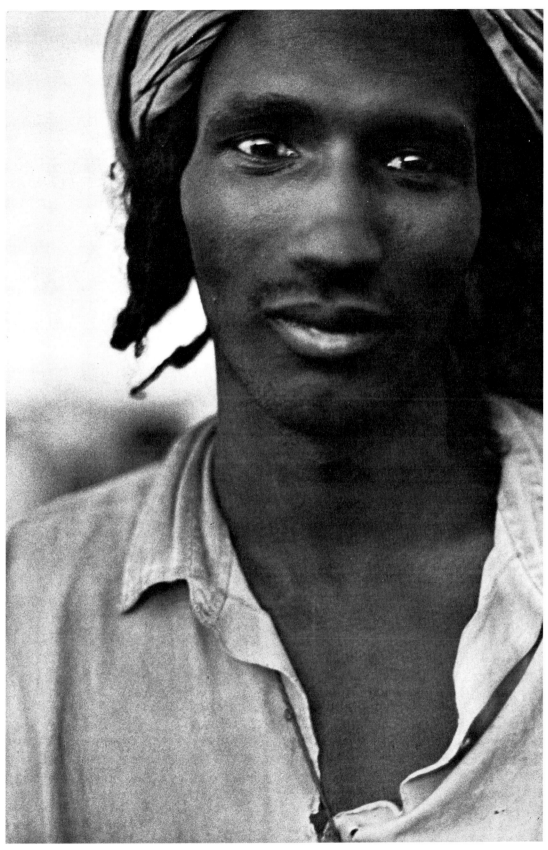

BERNARD PLOSSU

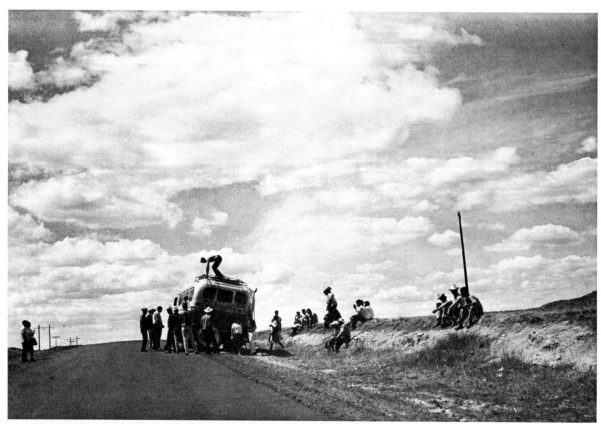

BERNARD PLOSSU

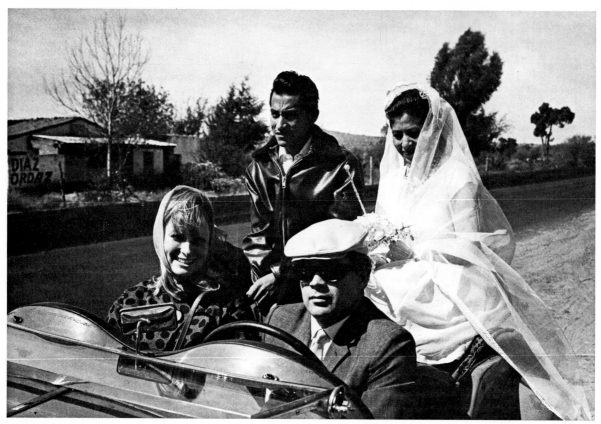

BERNARD PLOSSU

BERNARD DESCAMPS

BERNARD DESCAMPS

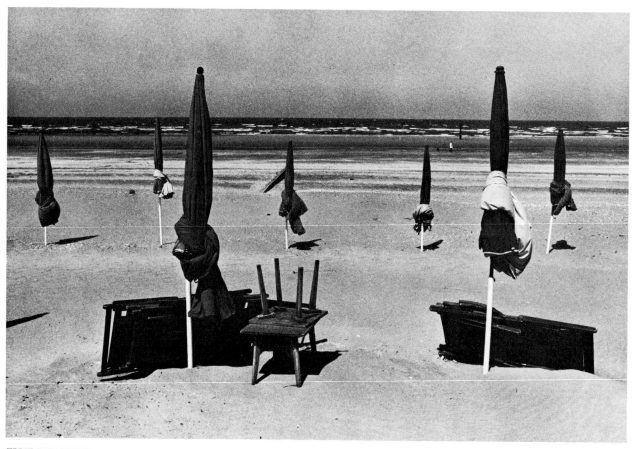

EDDIE KULIGOWSKI

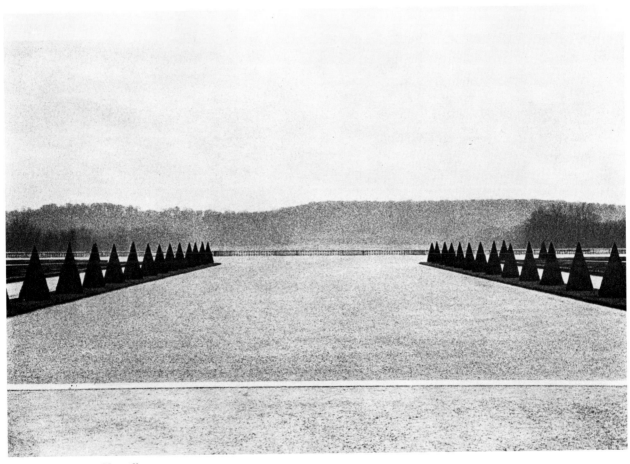

BRUNO REQUILLART, *Versailles, 1977*

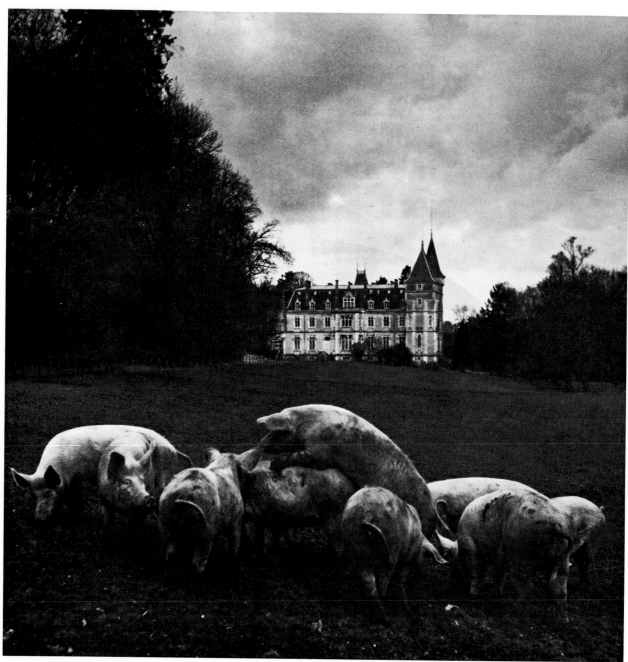

PHILIPPE SALAÜN

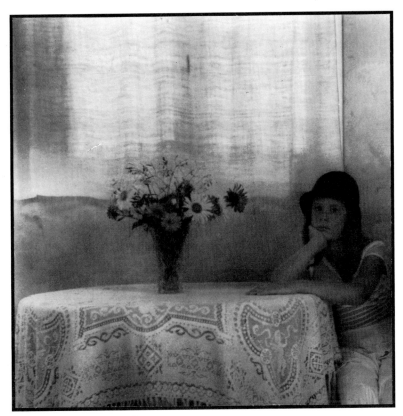

MONIQUE TIROUFLET, 1976

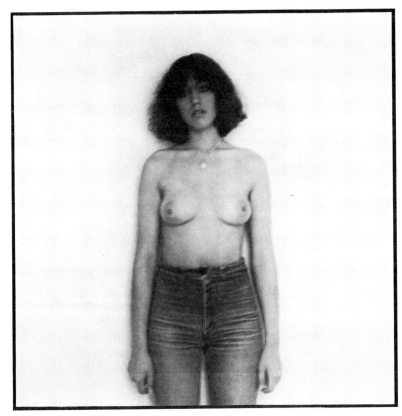

MONIQUE TIROUFLET, 1977

Four other photographers have become known during the last few years, moving in a similar direction, but producing work that is individually unique.

Philippe Salaün combines various elements in absurd and humorous juxtapositions bordering on the fantastic.

Monique Tirouflet takes intimate and intense pictures of the people and things around her; her pictures seem to come straight out of a family album.

Francis Jalain photographs the human presence that emerges as real portraits on the walls of houses, in the architecture of factories, and among the leaves in forests.

Janie Gras compares her photographs to islands in which figures of people appear minuscule and ridiculous.

Another group of photographers places great importance on how pictures relate to each other, how a new kind of discourse can emerge from changing their sequence or juxtaposing them. They feel that their ideas are very close to the narrative work of Robert Frank, William Klein, and Ralph Gibson, and believe that the goal of each of their projects is a book in which photographs are the materials for a new language. Among these photographers are Arnaud Claass, Jean-Louis Beaudequin, Eva Klasson, and Christian Sarramon.

PHOTOGRAPHY AS AN INTERDISCIPLINARY ART

Photography, which has created a new iconography, has become more and more important to people who use it in their work, in their research, or for demonstration purposes. It is hard to think of a field in which photography does not have its place, whether it is used as documentation or as a reproduction technique, as an object of fascination, or as a piece of evidence. Several plastic artists are presently making use of the principles of photomechanics, and a new realist movement seems to be coming to the fore.

Christian Boltanski, for example, integrates photography into his work in the plastic arts and uses amateur photography in an attempt to reveal our relationships with our memories, our past, and our childhood.

By pressing her face against the glass of copying machines, Nicole Métayer has managed to transform a utilitarian machine into a creative technique and has, in a certain sense, produced a self-portrait of woman at work.

In an effort to redefine the specific nature of the photograph, Roger Vulliez tries to modify its overly rigid frame by inserting himself in it as subject.

The writer Denis Roche makes self-portraits using a delayed-action shutter release, and has questioned the "reality" of photography in several of his books.

Film directors like Alain Resnais, Agnès Varda, Jean-Luc Godard, and Chris Marker are aware of the effectiveness of stills and have used them in several of their films. We have not heard the last of the photo-novel, a so-called minor genre. In 1976 some high-school children in Dieppe made a photo-novel with the help of one of their teachers in order to revive the form and also to portray the isolation of school environments. And every month Chenz and Gébé invent imaginative photo-novels in *Hara-Kiri*. Millions of people everywhere have formed very close relationships with photography: It allows them to express themselves and to quickly record their desires, their obsessions, their joys, or their sexuality. Anonymously they are building a collective history that may one day surprise us. But that is another story that I will try to tell some other time . . . the story of how we cover up our tracks.

FRANCIS JALAIN

JANIE GRAS

ARNAUD CLAASS

JEAN-LOUIS BEAUDEQUIN, *Ivory Coast*, 1976

ROGER VULLIEZ, *Self-censorship Using Ferricyanide*

NICOLE MÉTAYER

CHRISTIAN SARRAMON, *Paris,* 1975

CHRISTIAN SARRAMON, *Rio de Janeiro,* 1976

AGNÈS VARDA, From the film *Daguerréotypes*, 1975

LIST OF PHOTOGRAPHERS CITED

Abbott, Berenice
Albin-Guillot, Laure
Appert, E.
Atget, Eugène
Barbey, Bruno
Bauret, Jean-François
Bayard, Hyppolite
Beau, Jules
Beaudequin, Jean-Louis
Boltanski, Christian
Boubat, Edouard
Boucher, Pierre
Bourdin, Guy
Braquehais
Brassaï
Brihat, Denis
Cajart, Etienne
Caron, Gilles
Cartier-Bresson, Henri
Charbonnier, Jean-Philippe
Charles, J.
Chenz
Chevalier, Charles
Chrétien, Gilles-Louis
Claass, Arnaud
Clergue, Lucien
Dagbert, Alain
Daguerre, Louis Mandé
Decker, Marie-Laure (de)
Delluc, Michel
Demachy, Robert
Demeny, Georges
Depardon, Raymond
Descamps, Bernard
Dieuzaïde, Jean
Dillaye, Frédéric
Disdéri, Adolphe
Doisneau, Robert

Dornac
Dumas, Nora
Ernst, Max
Franck, Martine
Frank, Robert
Freund, Gisèle
Gaumy, Jean
Gautrand, Jean-Claude
Gébé
Gloaguen, Hervé
Gras, Janie
Hamilton, David
Hers, François
Herschel, John
Hine, Lewis
Izis
Jalain, Francis
Jarnoux
Kalvar, Richard
Kertész, André
Klasson, Eva
Krull, Germaine
Kuligowski, Eddie
Laboye, Roland
Lartigue, Jacques-Henri
Laurent, Michel
Legall, Pierre
Le Gray, Gustave
Le Querrec, Guy
Le Secq, Henri
Lumière (Frères)
Marey, Jules
Masclet, Daniel
Méliès
Merzagora, Jean-Paul
Métayer, Nicole
Moral, Jean
Muybridge, Eadweard

Nadar
Nègre, Charles
Newton, Helmut
Niépce, Joseph Nicéphore
Nori, Claude
Peress, Gilles
Petit, Pierre
Plossu, Bernard
Puyo (commandant)
Raimond-Dityvon, Claude
Ray, Man
Regnault, Victor
Requillart, Bruno
Riboud, Marc
Riiss, Jacob A.
Roche, Denis
Ronis, Willy
Salaün, Philippe
Salomon, Adam
Samuel, Antony
Sarramon, Christian
Savitry, Emile
Schall, Roger
Seeberger (Frères)
Sieff, Jean-Loup
Silhouette, Etienne (de)
Stieglitz, Alfred
Sudre, Jean-Pierre
Tabard, Maurice
Talbot, William Henry Fox
Thersiquel, Michel
Tirouflet, Monique
Vals
Vulliez, Roger
Weiss, Sabine
Zuber

Boubat, Edouard. *Woman.* New York: Braziller, 1973.

Brassaï. *The Secret Paris of the 30's.* Translated by Richard Miller. New York: Pantheon, 1976. London: Thames and Hudson, 1976.

Cartier-Bresson, Henri, and Shaplen, Robert. *The Face of Asia: Photographs by Henri Cartier-Bresson.* New York: Viking Press, 1972.

Daguerre, Louis J. *Historical and Descriptive Account of the Various Processes of the Daguerreotype and the Diorama.* Millwood, New York: Kraus Reprint Company, 1969.

Ernst, Max. *Une Semaine de Boîte: A Surrealistic Novel in Collage.* New York: Dover Publications, 1976.

Freund, Gisèle. *The World in My Camera.* Translated by June Guicharnaud. New York: Dial Press, 1974.

Hamilton, David. *The Best of David Hamilton.* New York: William Morrow, 1976.

————. *Bilitis.* New York: Camera Graphics, 1977.

————. *La Danse.* New York: William Morrow, 1974.

————. *David Hamilton's Private Collection.* New York: William Morrow, 1976.

————. *Diary of Sir David Hamilton.* Edited by Philip Roberts. New York: Oxford University Press, 1975.

————. *Dreams of a Young Girl.* New York: William Morrow, 1977.

Hine, Lewis W. *Men at Work.* New York: Dover Publications, 1977.

Kertész, André. *André Kertész: Sixty Years of Photography.* Edited by Nicolas Ducrot. New York: Penguin, 1978.

————. *Distortions.* New York: Alfred A. Knopf, 1976. London: Thames and Hudson, 1976.

————. *J'Aime Paris: Photographs Since the Twenties.* New York: Viking Press, 1974. London: Thames and Hudson, 1974.

————. *Of New York.* New York: Alfred A. Knopf, 1976.

————. *Washington Square.* New York: Penguin, 1975.

Lartigue, Jacques H. *Les Femmes.* New York: E. P. Dutton, 1974.

————. *Diary of a Century.* Edited by Richard Avedon. New York: Penguin, 1978.

Le Gray, Gustave, and Croucher, J. H. *Plain Directions for Obtaining Photographic Pictures by the Calotype and Energiatype, Also Upon Albumenized Paper, Etc., Etc.,* Parts 1–3. Reprint of 1853 ed. New York: Arno Press, n.d.

Muybridge, Eadweard. *Animals in Motion.* Edited by Lewis S. Brown. New York: Dover Publications, 1957.

————. *Human Figure in Motion.* New York: Dover Publications, 1955.

Newhall, Beaumont. *The Daguerreotype in America.* 3d rev. ed. Magnolia, Mass.: Peter Smith, n.d.

————. *The History of Photography: From 1839 to the Present Day.* Boston: New York Graphic Society, 1964.

Newton, Helmut. *Sleepless Nights.* New York: Simon & Schuster, 1978.

————. *White Women.* New York: Stonehill Publishers, 1976.

Nuridsany, C., and Perrennou, M. *Photographing Nature: From the Magnifying Glass to the Microscope.* Translated by J. W. Steward. New York: Oxford University Press, 1976.

Ray, Man. *Man Ray: Photographs, 1920–1934.* New York: East River Press, 1975.

ABOUT THE AUTHOR

Claude Nori was born in Toulouse, in the south of France, in 1949. In 1968 he left Toulouse for Paris, where he was an active participant in the events of May 1968.

He studied film for a time, and then went to Italy to work as a photographer and later as art director for the magazine *Photomese*. Until 1973 he was on the staff of several magazines and newspapers, including *Vogue, The Daily Telegraph,* and *Playboy.*

In 1975 he founded the first French underground critical journal on photography, entitled *Contrejour,* which was concerned with the picture as a social exercise and a means of expression. The newsroom of *Contrejour* became a meeting place and forum for "la photographie actuelle" [photography now].

Nori publishes an annual volume dedicated to young photographers, runs a gallery, directs workshops, and organizes foreign exhibits. His own photos have been exhibited throughout Europe and in the United States.